HAUNTED
GLOUCESTER, SALEM AND CUMBERLAND COUNTIES

KELLY LIN GALLAGHER-RONCACE

Published by Haunted America
A Division of The History Press
Charleston, SC
www.historypress.net

Manufactured in the United States

ISBN 9781467136242

Library of Congress Control Number: 2017938345

Notice: The information in this book is true and complete to the best of our knowledge. It is offered without guarantee on the part of the author or The History Press. The author and The History Press disclaim all liability in connection with the use of this book.

This book is dedicated to many people—some of this realm and some who have passed on. Thank you to my family and friends who have given me endless support in all of my endeavors, no matter how outlandish and impossible they may seem.

CONTENTS

PREFACE

In October 2012, I climbed into a yellow school bus and traveled through Salem County, New Jersey, to visit a handful of haunted locations with Revolution Tours and Jersey Unique Minds Paranormal Society. At the time, I was a features writer for the *South Jersey Times* and NJ.com and was gathering information about the tour in order to write a fun story for my newly created seasonal series, "Haunted Adventures."

It was in September, while I was planning my Halloween event coverage for the season, when a co-worker, reporter Jim Cook Jr., suggested I create and write the series for Halloween season.

In addition to the Historic Ghost Tour of Salem County, I wrote about haunted attractions on Morey's Piers in Wildwood, Eastern State Penitentiary in Philadelphia and Cowtown in Pilesgrove.

The stories appeared in the *South Jersey Times* throughout October, helping readers find fun places to go for a good scare during Halloween time.

While I love haunted attractions and being scared out of my wits by a highly skilled zombie or a perfectly sane man wielding a chain saw, it was while I was on the Historic Ghost Tour of Salem County that I realized I wanted to be more involved in the world of the paranormal.

Ever since I was a little girl, I've been interested in hauntingly creepy ghost stories. I've been watching paranormal research shows like *Ghost Hunters* and *Ghost Adventures* since they first hit the airwaves, and I enjoy learning about the history associated with many of the hauntings in New Jersey and across the globe.

My story about the Historic Ghost Tour of Salem County appeared online at NJ.com on October 17, 2012, and also ran in print in the *South Jersey Times* under the "Haunted Adventures" headline.

Hoping to make my goal of getting more involved with the paranormal a reality, I decided to apply to become a paranormal investigator with Jersey Unique Minds Paranormal Society (JUMPS) shortly after interacting with the team during the tour.

Founded in 2007 by Doug Hogate Jr., JUMPS is a nonprofit ghost research organization based in Salem County that conducts professional, scientific investigations for clients who believe they are experiencing ghost activity in their home or business or on their property.

After Halloween season came to an end and I began investigating with JUMPS, Cook suggested I continue my scary scribing but change the name to something that would convey the idea that the stories were going to be about actual hauntings, as opposed to those with a howling werewolf soundtrack playing in the background.

And so, my weekly column, "Paranormal Corner," was born.

The first "Paranormal Corner" appeared in the *South Jersey Times* on Monday, November 12, 2012, and the column ran nearly every week through October 2016. At that point, I transferred into the NJ Advance Media Entertainment Team, and "Paranormal Corner" slowly went by the wayside. I didn't stop writing about the paranormal; my ghost writing just took a different direction and lost the title. I put together packages about Jersey's ten most haunted taverns, thirteen creepy places to visit on Friday the Thirteenth and thirteen times the Jersey Devil has been spotted in the Garden State.

In December 2015, while "Paranormal Corner" was still going strong as a weekly column, I was contacted by an editor at The History Press who had seen my work on NJ.com. The editor proposed a contract for a haunted compilation of ghost stories surrounding Gloucester, Salem and Cumberland Counties—an area that was formerly known as West Jersey.

Having experienced many hauntings in these counties through my involvement with JUMPS, I took on the project with reverence, and it has finally materialized in the book you are now holding in your hands.

Acknowledgements

When researching and investigating the paranormal, it definitely takes a village to produce a book that puts so many ghost stories in one place for readers to easily enjoy. There are many people who have assisted me in this journey into the unknown, and I'm going to attempt to thank each and every one of them here. This would not have been possible without every single one of you, and I appreciate you all to the full moon and back.

I would like to thank The History Press for finding my writing interesting and good enough to ask me to pen this ghost story book for them. You definitely made my dream come true.

Thank you to my former co-worker and forever friend Jim Cook Jr. for inspiring me to take on a weekly column about the paranormal. What other newspaper has regular paranormal content every week? Well, there may be another out there, but none that I know of. Jim's idea led to my getting offered a contract for this book, so to him, I am forever grateful.

Thank you to the *South Jersey Times* and NJ.com for allowing me to write "Paranormal Corner" every week for nearly four years. They took a big chance allowing ghost stories to appear in the publication every week, and it very much paid off—at least it did for me.

Thank you to Jersey Unique Minds Paranormal Society and Doug Hogate Jr. for accepting my application back in 2012 and teaching me so much about paranormal research and investigating. Without you and the team, none of this would be a reality.

ACKNOWLEDGEMENTS

Thanks to Gaynel and Craig Schneeman and their resident ghosts at Barrett's Plantation House Bed and Breakfast. I'm so glad I have gotten to know you both in addition to Pumpkin and his spiritual companions. The inn is one of my favorite spots in New Jersey.

Thank you to Jennifer Jones, executive director of the Salem County Chamber of Commerce, for sharing her memories about Johnson Hall in Salem City with me for this book. Also, thank you for always being such a good friend.

Thank you to Gregg Jones, Greenwich's resident ghost expert and ghost tour guide, for spending a day taking me all around his beautiful and historic town and sharing all of its haunting secrets with me. Greenwich has truly turned into one of my favorite little Jersey towns.

Thank you John Ogbin for connecting me with Gregg in order to get all the great Greenwich stories.

Special thanks to my family for their unwavering support.

Thank you to my mother, Linda Gallagher, for always supporting, encouraging and pushing me to be the best. Rest easy until we meet again.

Thank you to my father, John H. Gallagher Jr., for being my biggest cheerleader for as long as I can remember.

Thank you to my daughter, Rene' Roncace, for putting up with my constant writing and always making me laugh when I need it most.

To my friends, what can I say? Thank you all for always encouraging me to do my best, keep going and never give up. You guys are my lifelines. Special thanks to Michael Shannon for sending that video when I needed that final push—"Just Do it!"

And thank you, reader, for picking up this collection of fun, fascinating and sometimes frightening ghost stories.

MY JOURNEY INTO THE UNKNOWN

I was about twelve years old when my parents finally, for the first time, left me home alone while they went out grocery shopping. Even though they would only be gone for maybe an hour, I was feeling quite grown up, hanging out in our big two-story house all alone.

I was in my playroom—a downstairs room where I kept all my favorite Barbie dolls, books, art supplies and records—you know the type of space I'm talking about.

After my parents had been gone for about a half hour, I ventured out of the playroom and into the family rec room—a room where we would gather to watch television, play board games and listen to music.

It was broad daylight. The sun was shining through the sliding glass doors that led out to the patio, backyard and above-ground swimming pool where I spent the majority of my summer days. I used the bathroom, which was located just off the rec room, and was headed back to the playroom when I had my first official paranormal experience. Well, at least I think I did. I have questioned the events that took place that day for the past thirty-some years.

Sitting on a small table near the far wall of the rec room was my record player. It was an old-style record player with the slide lever you had to pull all the way down and then let up to the center position, thus allowing the turntable to, indeed, turn.

It was the kind that shouldn't simply turn on by itself with no one there to pull that lever down.

However, from what I can recall—and I've tried to debunk the incident, even forget about it, several times over the past three decades—that's exactly what happened that day.

As I was walking back through the rec room to the playroom, that lever slid down, clicked back up into the center position and the turntable began to turn, all on its own.

There was no record on the turntable at the time, but if there had been, music would have filled the empty house—empty except for me, a first-timer.

I ran back into the playroom and slammed the door shut behind me. I stayed cowered in my safe zone until I finally heard our big red and silver conversion van pull back into the driveway that was located right outside the playroom window. Once I knew Mom and Dad were inside the house, I rushed out of the playroom and up the stairs to the kitchen to help unpack groceries.

I don't think I ever told them about the incident, and nothing else significantly paranormal ever happened again in my childhood home. Perhaps some long-lost relative was watching over me since it was my first time home alone and they wanted to make themselves known. Whatever the case, that brief, frightening moment was one of the rare but compelling childhood experiences that sparked my interest in the paranormal, which only grew stronger and stronger as I grew older.

EARLY UNEASY FEELINGS

The record player incident is one of my very first memories of experiencing something paranormal—one that actually made me think I was in the presence of a ghost.

But thinking back now, I believe I may have had my first paranormal experiences several years before that unsettling day in the rec room of my childhood home.

When I was just a kid, my mother and grandmother supervised a youth organization that met at an old church building in Penns Grove, Salem County, twice a month. The church is now abandoned and crumbling into disrepair.

At the time when we were meeting there bimonthly, the building no longer served as a church, but it had once witnessed many years of worship within its walls. In addition to a large sanctuary, the historic building had a large

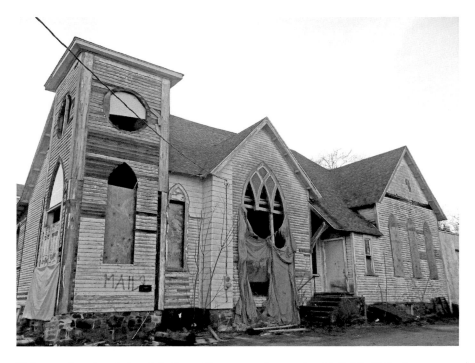

This now-abandoned church in Penns Grove was where author Kelly Lin Gallagher-Roncace first experienced the paranormal. *Author photo.*

lobby area, a gigantic kitchen with at least two stoves, a dining room big enough to hold banquets for hundreds and a fully finished basement. Even today, when I picture the stairs that led down to that basement, my stomach does a little flip.

While I have many wonderful memories of being in that church with my family and friends for our meetings, events and parties, I also remember—like it was yesterday—the strange feelings I got when I went into certain areas of that building.

In the main meeting room, where we held our bimonthly organizational gatherings, there was a separate storage area behind where the pulpit once stood. The storage area ran the entire length of the meeting room and had three doorways that connected it to the main room.

One of the places where I felt the most uncomfortable was back in that storage area.

Every time I stepped into that back area, I would feel every hair on my body stand up; my heartbeat would accelerate, and I could literally feel the air around me grow heavier as if it was going to smother me. I was only eight

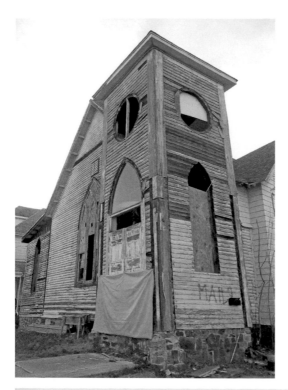

This now-abandoned church in Penns Grove was where author Kelly Lin Gallagher-Roncace first experienced the paranormal. *Author photos*.

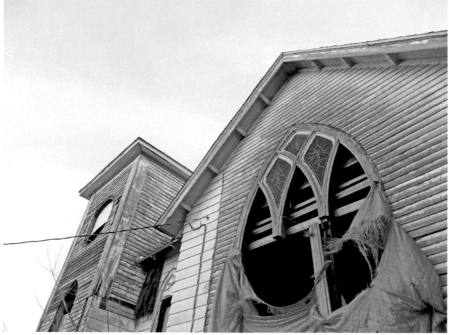

or nine years old, so I didn't realize what I was experiencing. I was a little kid in a creepy, old, dark room, so I thought I was just afraid of the dark.

But there was another area of the old church building that was in a much more wide-open space that affected me even more than the storage room did.

The restroom was down a short hallway off the lobby and just outside the kitchen door. It was also right across the hall from the basement steps.

Unlike basements in most private homes, the church's basement was designed like the lower level of a home.

There was no basement door to walk through, cutting off the steps from the rest of the upper area and leading to a narrow staircase that took you down into a dark, dank subterranean cavern. The wide stairway to the basement was a normal staircase, similar to one that would lead to a lower floor in a home.

However, these seemingly normal-looking stairs led to an area where there seemed to be a horde of invisible eyes watching me every time I passed by. I could feel them looking at me. Perhaps it was my imagination. After all, I was just a little kid. But you can't fake the chills or that empty feeling that develops in the pit of your stomach when you involuntarily go into panic mode.

When I grew older, I discovered that the basement was a place where the men would gather while the women met upstairs. Apparently, there was a pool table down there and other makings of what we would call a "man cave" today, but I never stepped foot on so much as the top step, much less descended into that ominous basement to get a look for myself.

It's been nearly thirty years since I was last inside that old church. The building is still standing, but it's in severe disrepair.

Now that I'm older and realize that what I was really experiencing inside that massive building was paranormal, I would love to return to the old church with some ghost-hunting equipment and conduct an investigation. Maybe I could make contact with whoever—or whatever—used to watch me when I walked by all those years ago.

GROWN-UP HAUNTINGS

During my four-plus decades on earth, I have lived in only two homes—three if you count the mobile home I lived in for one year just after I got married.

My childhood home never seemed to be haunted until that one day when my parents left me home alone and I witnessed my record player come to life on its own.

But the small house that I moved into in 1994—which I still live in to this day—has seemed to be occupied by someone I can't see since the night I arrived.

My one-story, three-bedroom Salem County home was built in the 1920s as a part of one of the villages built for the employees of DuPont Chambers Works. Several people have called this house home since it was built, including an elderly lady who lived here until she died and, later, a younger woman who also lived out her life calling the house that is now mine home. I don't think either one actually died while inside the house, but from what I've been told, my house was the elderly woman's lifelong home.

I can remember the first night I slept in my house like it was just last week. There were strange noises and eerie feelings, but I chalked all that up to being in a new place that was particularly old. And even though I was a bit uneasy, the house did feel like home.

Since that first night, I have experienced what I call "minimal paranormal activity" within my own walls.

Early one morning many years ago, I felt someone sit on the end of my bed. I was just waking up—my eyes were still shut—and I assumed it was my then husband. However, when I opened my eyes and looked toward the spot where I expected to see him sitting, there was no one there. I looked at the clock, and he had left for work at least a half hour before I felt the pressure on the end of the bed.

That was creepy.

Objects have moved—some have seemed more like they were thrown—across the room several times, including once when my husband and I were in a disagreement. We were involved in a heated discussion when a glass bottle full of Italian salad dressing flew off the top of the refrigerator in the kitchen and landed in the middle of the dining room floor, at least six feet away.

Curtains have flown up to the ceiling and settled back in place covering a completely closed window, and I've heard things fall in other rooms but found nothing out of place upon inspection.

The one incident that leads me to believe my resident spirit could be the elderly lady who lived here for so many years involves a minor emergency with my daughter.

It was early in the morning, and my husband and I were still sleeping. In my slumber, I slowly became aware of a steady tapping sound coming

from the area where the dresser stands in my bedroom. The sound was loud enough that it roused both of us from our deep morning sleep.

My husband got out of bed first and tried to find the source of the strange tapping sound, but he couldn't find a reason for it.

He went to use the bathroom, and when he returned to the bedroom, he asked if I had thrown up in the toilet in the middle of the night. I told him I hadn't, and he informed me there was evidence in the bowl that someone had been nauseated the previous evening.

The only other living person in the house who could have thrown up in the toilet bowl in the middle of the night was our five-year-old daughter.

We went into her bedroom to check on her, and she had indeed woken up sick in the middle of the night. The toddler had woken up, gone into the bathroom to throw up and then went back to bed, all without waking us. She's always been very independent. However, she had a fever and was still feeling ill, so our protective ghost woke us to alert us to our daughter's illness.

Thank you, protective spirit.

The activity in the house is never consistent but is often present.

One evening not too long ago, I was home alone watching a horror movie on television when my occasionally haunted house made itself known once more.

My dog TJ was sitting on the couch with me when we suddenly heard a loud bang come from the direction of the kitchen. It sounded like something heavy fell to the floor.

It startled TJ and me so much that we both nearly got whiplash snapping our heads around to look in the direction of the sound.

Since that bang was the first and only strange sound I had heard that evening, I just blew it off, dismissing it as possibly something shifting in the sink full of dirty dishes.

Don't judge me. I'm a busy lady.

So, I returned to my movie, and TJ returned to relaxing.

Not two minutes later, TJ and I heard more movement in the kitchen. It wasn't the wind or dishes shifting in the sink. The noises were undeniably being made by someone or something moving around in the next room. I looked at TJ, and he looked at me, and we both knew what was coming next.

I had to go check it out.

Being a paranormal investigator, this is the kind of thing I ask for when out in the field, but honestly, I'd rather not experience the unexplained while sitting in my own living room.

I asked, out loud, for whomever was making all the noise to please stop because they were "freaking me out." Shortly after my request, all was quiet.

The movie ended with Damien flashing his evil stare as if bidding me goodnight, so I turned off the television and went to bed.

Almost immediately after turning off my bedroom light for the night, the noises resumed, this time in the living room—where TJ and I had just been sitting—just outside my bedroom door.

I was slightly creeped out from the movie and lying in my bedroom all alone in the dark. Was I a bit unnerved? Yes, but I had had enough of the nonsense.

"Stop it!" I yelled aloud to my invisible visitors, and finally, my house was quiet.

Even though I'm a paranormal investigator and enthusiast who seeks out haunted locations, it's different when the activity is in your own house. But when you know of a haunted spot and can't get permission to do an investigation, it can be quite frustrating.

I came across just such a place more than ten years ago. Even though I never took my equipment into this specific building or recorded any evidence, I know it's haunted, and I'm going to tell you all about it right here, right now.

I won't mention the name of the place or any of the people, in order to protect it, the employees and myself, of course.

In between newspaper gigs, I worked at a South Jersey elementary school. That's all I'll say about that as to not give away which school it was.

It wasn't until I had worked there for a few months that a co-worker told me about a little girl named Elijah.

She said Elijah was ten or eleven years old, loved to play and often whispered into the teachers' ears. Also, Elijah was dead.

The story that has been told over the years is that Elijah attended the school maybe one hundred years ago. She was either sick or had an accident and died in the coat closet on the bottom floor of the school. No one knows if that account is accurate, but that's the legend that surrounds Elijah's memory.

Even though her story could be incorrect, her spirit—or someone's spirit—is definitely present in the school where I worked for five years.

It took a while, but once she got to know me, Elijah made herself known several times in big, undeniable ways.

My first significant interaction with Elijah occurred in a first-floor classroom. It was lunchtime, so all the students were in the cafeteria, and the teachers

were either in there with them or elsewhere on lunch break. I had been in another teacher's room taking a break but remembered I needed something that I left in the classroom where I had been before the lunch bell rang.

I excused myself and returned to the classroom alone. The particular room I was headed to was a big one with shelves of toys and books, a door to the outside playground and a coat closet. Was it *the* coast closet? I'm not sure, but given what happened in that room that day, it very well could have been.

I walked into the empty room all by myself and headed for the coat closet to grab my purse. Out of habit, I said hello to Elijah. I did that often, especially when I was alone. Suddenly, I heard one of the electronic video games that was sitting on the toy shelf come to life. The game uttered one digital blip, as if someone turned it on.

"Elijah, is that you?" I asked out loud to someone I could not see.

Two pings sounded from the game in response to my question.

I must admit—the phantom beeps were sort of freaking me out.

"Is that you doing that?" I asked again.

That was when the video game went crazy. Buzzing blips, powerful pings and boisterous beeps began pouring out of the device like someone had just pulled its handle and won a million dollars. That was enough for me. I grabbed my purse and hurried out of the room.

Am I proud of that reaction? Not at all. But that was the first time I had attempted to investigate a haunted location alone and actually got an intelligent response. Even though it was broad daylight and the middle of the day, the interaction left me slightly unnerved.

While Elijah seemed to like the video games that the live children played with every day, I found out the creepy way that she didn't like eerie Halloween music.

Each Halloween, I would turn one area of the school into a walk-through haunted house for the kids to enjoy. There were scary props, flashing lights and a horrifying soundtrack. Well, at least there was supposed to be a horrifying soundtrack.

With help from a couple other teachers, I finally completed the haunted house and was preparing to bring the first group of students through. With the normal lights turned off, and the spooky lights turned on, I pressed play on the CD player containing the haunting Halloween harmonies. The soundtrack began to play, filling the room with the sounds of scary screams, hissing cats and a windy thunderstorm.

And then, all of a sudden, the sounds ceased. The CD stopped playing all on its own.

I figured maybe there was a glitch on the disc so I took it out, blew on it—because that fixes everything, right?—put it back into the player and pushed play once again.

Just after the CD began playing again, it quickly stopped again—but in a different spot—telling me it wasn't something wrong with the CD itself.

I pushed play once more, but this time, instead of hearing the sounds of a severe thunderstorm, I heard what we paranormal researchers call "white noise." White noise is a sound that is produced by combining the sounds of all different frequencies together. If you were to take all of the imaginable tones that a human ear can hear and combine them together, you would have white noise.

Within the white noise, I could hear what sounded like whispers and voices. I couldn't make out any words, but I quickly figured out what was happening. Elijah didn't want me to play the scary soundtrack. Maybe she was afraid the background noises would scare the kids too much. Maybe she didn't like thunderstorms when she was alive. Whatever it was, I could not click the stop button quickly enough.

I apologized, and the haunted house went off without a hitch—and without a soundtrack.

And the creepiness of the haunted school didn't stop there.

Later that evening, while handing out candy to trick-or-treaters at my home, I found out that the CD player wasn't the only haunted house prop that Elijah had messed with during the haunted house at school.

One of the students who attended the school and had walked through the haunted house earlier that day came by my house to get some candy. After I took down the haunt at school, I set up some of the leftover Halloween props outside my house to set the mood for the holiday. One of the props I set outside was a big, black, plastic rat.

The student had remembered the rat from his visit to my haunted house a few hours prior.

"I saw you moving that rat today," he said.

I hadn't been moving the rat during the haunted house. Actually, I was nowhere near the rat during the haunted house, so I asked him what he was talking about.

"I saw you behind that table. I saw your hand on the rat making it move up and down," he said.

The table that the rat was sitting on was flush with a wall, making it impossible for anyone to be behind the table. But I already knew there was no one behind that table and no one had been moving the rat—no one living, that is.

Also, the rat isn't an animated prop, so it couldn't have been moving on its own either.

I thanked the boy for telling me about his experience with the rat, even though he didn't realize he was having a paranormal experience until I explained to him that what he saw was not what he thought he had seen.

In the same area of the school, but at a different time, a student fell out of a chair and hit his head. Another instructional aide and I went to the classroom where the accident had occurred to make sure the child was all right. We were standing in the doorway when my co-worker turned to me and simply asked, "What?"

Confused, I asked her the same question in response.

She asked me if I had just said something to her, and I told her I had not.

Apparently, Elijah was worried about the student because my co-worker said she had just heard a whisper in her ear, asking her, "Is he going to be OK?" We were the only people in the doorway, and there was no one in the hallway behind us. She said she heard the soft voice plain as day, like someone had come up behind her and whispered the question into her ear.

After these and a few other unexplainable incidents that I witnessed while working at that old school, I inquired about bringing my equipment and a couple more investigators in to conduct a formal investigation of the location. However, my request was denied due to the fear of parents finding out about the school's resident ghost and feeling uncomfortable about their children attending classes there.

So, while I have no documented proof—no photos, audio or video evidence—I have a few of the most intense personal experiences of my life thanks to my five years as an instructional aide at that school.

As a paranormal investigator and enthusiast, working in a haunted school was quite enjoyable. I don't even mind when my spectral visitors stop by my home, but I don't really want to know who or what it is or why they sometimes visit. When I'm on an investigation, those are the answers we strive to receive. But sometimes, strange bumps in the night hit too close to home.

When a Ghost Hunter Experiences Death

In December 2012, my mother had a massive heart attack and lost her life. It was extremely sudden and a devastating shock to my father and me, not

to mention the many people she interacted with every day at her part-time jobs—a school bus assistant, dance studio office manager and seamstress who sewed for dance studios, marching bands and high school girls who needed their prom dresses altered.

Mom was outside with my dad putting Christmas lights on the bushes out in front of their house when she started having pains in her neck and arm.

I had spoken to her at 4:00 p.m. that day to tell her I was approved for a vacation day on December 3—the very next day—so we could go Christmas shopping.

By 6:45 p.m., my mom was gone.

I'm an only child, and my parents have always been involved in everything I've done from birth to adulthood, so the shock of losing her was overwhelming—it still is.

Every evening before her untimely death, Mom would sit down on the couch at the end of the day to relax and play her handheld electronic solitaire game—the kind that makes blips and blings when the digital cards are dealt and sings when you win.

The morning after she passed, my dad was on the telephone speaking with a representative from the Gift of Life Donor Program when I arrived at his house. They were discussing the possibility of donating some of Mom's organs in order to help others. The representative suggested harvesting tissue, some bones and Mom's corneas to donate to those in need.

I was standing by the coffee table where Mom's solitaire game was sitting quietly when—out of nowhere—the game made a noise. It played one of its digital tunes, loud and clear.

My dad turned around to see if I was playing with the game or if Phineas, their rescued cat, had accidentally stepped on the game, causing it to turn on.

I hadn't touched it. Phin was nowhere to be found. And the game had not actually turned on. The familiar game sounds came out of the contraption, but the game had not powered on.

Dad looked at me and I looked at him, and we both knew the reason behind the sudden sound.

We smiled and considered the game's sound Mom's way of telling us that she was happy to be helping people after death as she had helped so many during her incredible sixty-eight years of life here on earth.

Whether you believe that there is something more after our bodies die or you don't, there are some experiences that simply can't be explained. And

when you've gone through a terrible loss and are coping with grief, a sign such as a silly tune from a handheld game can give you hope that a loved one is still close by.

Then there are times when you receive a sign that they are, in fact, listening to you when you talk about them and the many memories they left you with.

One day while at work in our old Woodbury office, I was telling two co-workers about a big glass jar of mismatched buttons my mom—who was a seamstress for as long as I can remember—kept in her sewing room when I was a little girl.

I was telling my work friends that I was thinking about bringing the jar of buttons to my house, decorating it and letting it serve as a happy memory of my mom.

While I was talking about the jar of buttons, I was packing up and preparing to leave work for the day. Both of my co-workers agreed that I should get the button jar and put it in my own house to remind me of fun times from my childhood.

It was a cold day, so I decided to walk through the back section of our building where the printing press used to be and exit through the back door, which is closer to the parking lot.

That back section of the old building is a big, empty, warehouse-type of space that not many people used except for maybe the maintenance department or employees who cut through like me.

As I was walking through the big, empty room, I happened to look down and saw something black and shiny lying on the cement floor.

I thought nothing of it at first and continued to walk toward the back door. But after a few steps, I stopped in my tracks and said to myself, "What was that?"

I backed up, bent down and picked up a small, black button.

There's no good reason why that button was lying on the floor in the deserted backroom of our building.

The fact that I had just been discussing my mom's button jar and, out of nowhere, a button showed up directly in my path is a very strange coincidence. Then again, I've been told there's no such thing as coincidence and that everything happens for a reason.

"OK, Mom, I'll go get the button jar," I said to her with a smile.

So, sometimes, even when we're not expecting it, we will get signs from the other side.

It was February 2016, and I hadn't been on a paranormal investigation in quite some time. I wasn't actively running with JUMPS at the time, and

I was starting to worry that my passion for pursuing the paranormal was fading away with the tide.

However, it's at times like these when life will give you the signs that you need at just the right time.

One evening, I was out at a small restaurant in Salem County with a friend who I hadn't seen in several years when someone or something that couldn't be seen made its presence known.

It was late, and the establishment was about to close. My friend and I and a bartender who was cleaning up for the night were the only people in the room. As my friend and I chatted about the old days, our kids and what aches and pains we had developed now that we're "getting old," we heard the kitchen door swing open. The noise made us both stop talking and turn our heads around quickly to see what was going on. When I looked toward the kitchen, I saw the door swinging on its hinges before it finally stopped and settled back in place between the kitchen and the restaurant.

"What was that?" my friend asked, obviously disturbed by the seemingly unexplainable incident.

I got up and walked directly toward the door. At the same time, I asked the bartender if there was anyone else in the building.

Her answer was no.

I asked if there was a door leading from the kitchen to the outside and if it was locked.

Yes, there was a door, and it was indeed closed and locked. She said there was also a small table in front of the door.

As my friend and the bartender looked on apprehensively, I approached the now still kitchen door.

It was one of those doors that are always hanging between kitchens and restaurants—the kind on hinges that allow it to swing both ways, allowing the cooks and waitresses to walk out with an armful of delicious dishes and back into the kitchen with a tray of dirty ones.

When the door swung open on its own, it flew outward, into the restaurant. When I reached the door, I pushed it back into the tiny kitchen and gazed into the room.

It was dark inside, but there was enough light coming through the one window in the kitchen and the lights in the restaurant to see if there was someone in the small room or if it was, in fact, empty.

"Hello?" I spoke into the empty room. "Is anyone in here?"

In an attempt to debunk what appeared to be something paranormal, the bartender and I experimented with opening and closing different doors to

coolers, a walk-in refrigerator and the main entrance to see if there was a suction that would cause the kitchen door to swing. Nothing we did made that door move even an inch.

I asked for it to happen again, but the door sat unmoving for the remainder of the night.

I figured the strange activity was over for the night, but I was wrong. Just as we were about to leave, all three of us heard distinct tapping on the back bar. Just as we all looked in the direction of the sound, it ceased. After a couple seconds of uncertainty, I asked if whoever was tapping could do it again, and the tapping sound returned.

I asked the bartender if it was common for strange things to happen in the restaurant. She said she had heard many stories but hadn't had any experiences herself until that evening.

Then she told me that a few years earlier, a man died while playing a game of pool in the building.

Could that man be trapped in the establishment, playing pool and pulling pranks on the eatery's patrons? Or could it have been someone else? Whoever or whatever it was, the experience gave me the same goosebumps on my skin and butterflies in my stomach that I had always gotten when witnessing something that could possibly be paranormal. The incident and the way it made me feel told me that my love of ghost research is still as strong as ever.

A Journey into the Unknown

So, even though it wasn't until November 2012 that I became an official paranormal investigator, unexplained and strange experiences have been present in my life since I was a toddler.

Within these pages, you will read firsthand accounts of some of the investigations I have participated in since 2012. You will learn some of the rich history that lives in Gloucester, Salem and Cumberland Counties—the section of the Garden State that was once called West Jersey. And you will hear ghost stories associated with one of America's oldest colonial port towns.

So, sit back, relax, dim the lights—but not too much—and enjoy these stories of the hauntings of Gloucester, Salem and Cumberland Counties in New Jersey.

GHOSTS OF GLOUCESTER COUNTY

WHO'S HIDING INSIDE SHADY LANE NURSING HOME?

SHADY LANE NURSING HOME, GREENWICH TOWNSHIP

Hauntings can happen anywhere—homes, businesses, even out in a forest or farm field. But some locations are more prone to hosting lost spirits than others.

The walls of many hospitals, funeral homes and nursing homes absorb the energies of the thousands of different souls who enter this kind of facility and sometimes never leave, dying within its walls. Many buildings such as these have been standing for hundreds of years, making them hotbeds of spiritual energy.

A great example of one of these kinds of facilities is Shady Lane Nursing Home in the Clarksboro section of Greenwich Township in Gloucester County.

The Shady Lane Nursing Home building was purchased by Gloucester County in the 1800s to serve as an almshouse. The building has been renovated several times, but despite the upkeep, it began to deteriorate beyond repair in the 1990s, prompting the county freeholders and improvement authority to construct a new facility adjacent to the historic one.

The new Shady Lane Complex includes a sixty-bed nursing home—featuring ten private rooms and twenty-five double rooms, each with its own bathroom and shower.

The complex is also home to the Gloucester County Child Care Development Center, bringing the oldest and youngest generations together under one roof.

The original three-story building still stands and is home to several county offices, all on the first floor.

Shady Lane Nursing Home sits on one hundred acres of land that was originally known as the Lippincott Homestead and included a three-story, red brick building; Rattlesnake Spring, which provided water to the property; and the family burial plot.

County officials decided to purchase the property from Elizabeth Lippincott in 1860 and transform the homestead into the Gloucester County Almshouse, County Home and County Farm.

A stone building to house the insane was built about one hundred feet from the main building in 1867, but it had the capacity to hold only six patients.

The facility took on the name Shady Lane Nursing Home in 1961.

With such an active and long history, it's not surprising that there are a few residents who still reside at the home.

In November 2014, I joined a group of paranormal investigators to check out the many claims of strange activity inside the original Shady

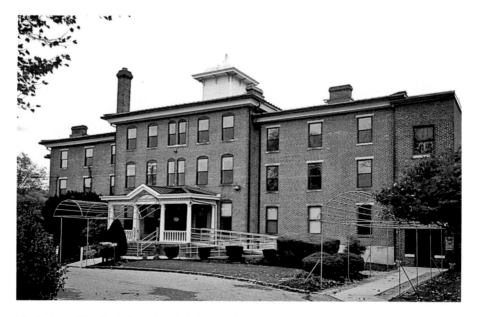

Shady Lane Nursing Home in Clarksboro. *Tiffany Hoffman.*

Lane Nursing Home facility. Many staff members who work in the building every day have reported hearing strange sounds, voices and footsteps; being touched; and even witnessing objects moving from one place to another.

During most investigations, I rely on audio recorders, K-2 meters (a device used to detect spikes in electromagnetic energy) and the Kinect video mapping system to detect paranormal activity. But every once in a great while, I'm privileged to experience what we in the trade call a "personal experience"—something that isn't caught on audio or video but happens directly to a person.

During the investigation at Shady Lane, I saw something with my own eyes that I cannot explain. And being a devout skeptic—all paranormal investigators must be somewhat skeptical in order to be able to make impartial decisions about evidence—I tried my hardest to debunk what I had seen.

The remarkable event took place in the portion of the basement that lies beneath the original section of the building.

When two additions were built in the early and mid-1900s, additional basement sections were also added and used for storage, activity rooms and medical examination rooms. However, the original section of basement remained run-down and somewhat creepy. I and three other investigators descended into the basement where we were to investigate the hallway and a few rooms in the lowest level of Shady Lane.

While conducting EVP (electronic voice phenomenon) sessions, monitoring K-2 and EMF meters and watching the Kinect video mapping system, we were alerted that two other investigators were on their way down to the basement to retrieve some equipment.

Investigators often carry walkie-talkies to communicate with one another while exploring a location, but it's still very possible to accidentally scare one another while we are creeping around in strange, dark places. For that reason, we try to warn others of our impending visits when we can.

When the call came in, I was standing in the dark hallway, just outside the rooms we were preparing to enter and investigate.

Not less than a minute after the call, I saw a small figure walk across the opening at the far end of the long hallway.

Without a thought otherwise, I figured the shadow was cast by one of the investigators who had come down to the basement to pick up some equipment.

I mentioned to the investigators who were with me that I had seen someone at the end of the hallway. One of them yelled out a "Hello" to let the investigator know we were also in the vicinity.

There was no answer.

The investigator who had shouted a greeting went to the end of the hallway to see if the other investigators had, in fact, come down into the basement, but once he arrived, the area where I had seen the figure cross was void of any humans.

Let me try to describe in detail what I saw. I was standing in a long hallway and saw a figure walk from right to left across the opening to my hallway—picture a letter *T*.

Knowing that someone was expected to come down into the basement, my brain instinctively told me it was a person walking across the opening of the hallway. The reason why the person wasn't there obviously had to be because she was moving quickly and was already out of earshot when the investigator who was with me called out to her.

However, when I walked to that end of the hallway myself a few minutes later, I was dumbfounded.

The end of the hallway was not a *T*-shaped path at all. There was a solid wall to my right. That was the direction from which the shadowy figure that I witnessed had come. The figure was walking in full stride when I saw it with my own eyes.

For a moment, my brain felt light and airy, almost faint. There was a solid wall—no windows, no doors—where the "person" I had seen had materialized. After I found my voice, I simply kept saying, "It's a wall. It's a wall!" I even pushed on the barricade a few times to assure myself that it was indeed a solid wall.

I tried to think of a way to debunk what I had seen—since that is what I do—but this time there was no way to write it off as something else. I had seen a humanoid figure walking from right to left across the hallway opening, but there was a solid wall on one side that would make what I saw impossible.

Even now, knowing it's impossible for a solid human to walk through a wall, my brain tries to dismiss it.

But in this field, sometimes you just have to sit back and let the possibility sink in that, yes, I did just see that with my own eyes.

While that experience was mine and mine alone, there were many incidents at Shady Lane Nursing Home that were documented on audio and video and submitted as evidence of a haunting.

One amazing incident was captured using the Kinect game system. The way it works is quite interesting. The game's sensor emits billions of tiny laser beams that translate into a stick figure when they pick up a human form—whether living or dead. That stick figure appears mirrored on the laptop screen. In other words, the figures will be reverse of where they are actually located.

The Kinect sensor was set up inside a room with two strange chairs—one a dentist's chair and the other a barber's chair. The laptop was placed on a metal folding chair in the hallway so it could be monitored by whichever investigators were in the area at a given time.

No investigators had entered the room with the strange chairs, yet when we looked at the monitor, we saw a small stick figure glowing in the middle of the otherwise dark screen.

The figure appeared to be in the back corner of the room trying to hide from us. A fellow investigator carefully entered the room and, guided by me and another investigator, tried to approach it.

When the investigator was finally next to the small figure, he stopped and began to try to communicate with it.

The Kinect sensor was picking up both figures and showed that the smaller of the two was curled up, possibly in one of the chairs or under a chair—it was hard to tell.

But while the investigator was talking to his invisible friend, he felt something tug on the hem of his shirt twice.

When he reacted to the physical touch, the smaller figure disappeared and didn't return.

Had it been a child lost in the basement from hundreds of years earlier? Could it have been a small patient who had died in the facility? We will most likely never know, but the Kinect didn't pick up anything other than human forms for the remainder of the evening.

Moving down the basement hall to the newer basement additions, another investigator and I decided to set up the flashlight game to try to entice a spirit to play.

I've used the flashlight game a few times, including during an investigation at Philadelphia's Eastern State Penitentiary while visiting death row and once at Barrett's Plantation House Bed and Breakfast in Mannington (which you'll read about later in this book). Sometimes it works and sometimes it doesn't—as with most paranormal research. It all depends if there is a spirit present to manipulate the flashlight, obviously, and if that spirit is strong enough to manipulate the object.

We set up the flashlight in an area of the hall where there was already an infrared video camera recording the surroundings and brought K-2 meters and an audio recorder along.

It was about 3:00 a.m. I unscrewed the lighted end of the flashlight so that it would flicker to life with the slightest touch and placed it on the concrete basement floor.

On this particular occasion, we communicated with someone for nearly forty-five minutes, using the simple, twist-on flashlight.

We began asking, as if someone was there with us, for someone to tap the flashlight and make its light come on.

The torch remained dark for quite a while. These are the moments when paranormal investigating can get frustrating. Some nights are very active from the start, while during other investigations, we spend hours in the dark and leave with nothing to show for it. Still, at other times, it takes only a short time for the spirits to warm up to us.

Finally, after continuing to ask if anyone was with us, the flashlight fluttered to life.

We took turns asking standard questions, like, "If you lived here, can you make the flashlight come on?" and "Did you work here? If so, turn the flashlight on, please."

The flashlight responded to many of the questions, illuminating brightly for every positive response.

Each time the flashlight was turned on in response to an inquiry, we would ask for the light to be turned back off so that we could continue communicating. And each time we asked, the light would turn off once more.

After asking general questions for a while, we decided to try to find out just who we were talking with. The great-grandfather of one of the investigators on this case had passed away while he was a patient at Shady Lane. We were curious to see if the spirit who was with us could possibly be that man.

"Do you have a grandson named Tim?" we asked.

Throughout the flashlight session, the bulb would flicker on at our request and extinguish slowly. However, when we mentioned Tim's name, the flashlight clicked on quickly and solidly and shone brightly for several minutes until we asked the spirit to please turn it back off.

This doesn't prove that whoever was manipulating the flashlight was indeed our friend's great-grandfather, but when the flashlight beamed on strongly when we asked if the spirit knew Tim, it was an emotional moment.

With a history of more than two hundred years and countless souls moving in and out of its walls, it's no wonder that Shady Lane Nursing Home is full of ghost stories and paranormal activity. A shadow that emerged from a solid wall, a tiny, neon-green stick figure on a computer screen and a blinking flashlight are just three pieces of evidence that show that Shady Lane most likely has several permanent residents.

STILL INCARCERATED AT GLOUCESTER COUNTY JAIL

WOODBURY

A building doesn't have to be old to be haunted.

The Gloucester County Jail in Woodbury was built and opened in the early 1980s and closed just thirty-odd years later in June 2013 due to a jail merger with neighboring communities as part of a regionalization of corrections services.

Instead of an ancient fortress like Eastern State Penitentiary or Burlington County Prison, the Gloucester County Jail is a modern, four-story structure on Hunter Street in Woodbury. The prison has small cells with heavy metal doors instead of metal bars to contain the inmates and a large, open community area in each wing with metal tables and bright lights instead of dirt-floored courtyards and solitary eating spaces.

The Gloucester County Jail was populated with as many as three hundred prisoners at any one time, so reports of strange activity in the cells, the common areas and the medical wing were quite common. Even though the prison was only open for three decades, the tragic incidents that transpired within its walls during those thirty years are most likely what served as fuel for the reported hauntings.

Some of the claims of paranormal activity inside the jail include hearing voices, banging and other unexplained sounds; seeing shadows and apparitions; being touched; and having objects move on their own.

After hearing of the paranormal claims and the stories of violence and death that occurred inside the Gloucester County Jail, a group of investigators and I decided to go in—with permission, of course—to see what kind of evidence we could gather to support the unexplainable reports.

The jail was totally locked down, with only one way in and one way out, while we were there conducting our investigation. Even though the facility had been empty for more than six months, it was still being operated as it had been for thirty years, under full surveillance.

One former corrections officer, who had worked at the jail for many years right up until its doors were closed, had a few personal run-ins with unexplained activity while making his rounds at the jail. The guard said he would hear loud taps and clangs while stationed inside a control room on the lower level of the building where he spent much of his time. The room was enclosed in glass with a view of the elevators, booking area and laundry room.

Any co-workers who needed to exit the building were required to approach the control room, tap on the glass and wait for him to unlock the heavy metal doors before they could pass by his station and exit to the outside. He was usually working on a computer, so when he would hear someone tapping on the glass, he would look up, see a staff member and unlock the door for the person to pass through to the outside.

One particular sergeant would use quick taps across several panes of glass all the way from the elevator, down the hallway to the exit door.

The guard became familiar with the sergeant's unique knock, since most employees would just knock on the window near where he sat to request for the door to be unlocked.

It was early one morning and he was at his post, working on the computer, when he heard the sergeant's familiar knock, but when he looked up from the screen, the hallway was empty.

The sergeant wasn't standing there waiting to move through the heavy metal doors because he had died some time before that day. What the officer heard from his post in the control room was a phantom knock. And that wasn't the last time he heard the sergeant's knock.

While this sergeant didn't die within the prison walls, he did spend a lot of time there, and some of his energy could be trapped there, including the energy that remembered his habit of knocking on the glass to get out of the building.

During the jail's short history, there were several deaths that occurred inside the prison. Approximately a dozen prisoners killed themselves there,

The former Gloucester County Jail, now the county Justice Department, seems to have a few prisoners who haven't yet been released. *Author photo.*

one died of an overdose in a lower-level holding cell and there was an accidental death that made headlines in 2003.

Bernard King was found dead in his cell with his arms handcuffed and legs shackled. It was determined that he was lying in such a way that he could not turn over to get a breath and therefore died of positional asphyxiation.

After King's death in that holding cell, countless prisoners were held there, but none was told of the accidental death that occurred in the spot where they were sitting. However, in the ten years between King's death and the jail's closure, at least a dozen crosses, all of different sizes and design, were carved into the paint on the walls of that cell.

In addition to the strange occurrences in that holding cell, corrections officers, staff members and prisoners have all reported seeing shadows and hearing voices and loud noises throughout the entire building.

The first sign I received that verified the staff members were not imagining things while on patrol at the prison came while I was investigating the lower level of the jail near the booking area where inmates used to be brought into the prison and were held before being placed into permanent cells.

I was in a large holding cell with two other investigators, and we were attempting to make contact with a prisoner who had died of an accidental overdose when a baggie containing narcotics broke while he had it hidden in a certain body cavity.

It was quiet in the area where we were investigating, until we were suddenly startled by a loud bang that sounded like a metal mop bucket being thrown across the room and bouncing to a stop on the cement floor. Once the shock wore off, we exited the cell and began looking for the source of the loud clang.

The noise definitely came from just outside the holding cell we were standing in when we heard the bang. The booking area wasn't a very large space, and we could see the entire room from anywhere in the vicinity.

As we inspected the area, we saw that nothing was out of place. There was no metal bucket knocked over. There wasn't even a broom leaning up against a metal trashcan as if it had fallen onto it and caused the clang. The unexplained sound was, however, an exact match to the one that several booking officers had reported hearing while working in that section of the jail. As a paranormal investigator, one of my goals is to witness activity that has been reported and try to debunk or verify that activity. We all heard the clang, and none of us could debunk the noise.

Experiencing activity that has been reported by jail employees and hearing the metal bang was a great way to start the investigation, so we were excited to get to other areas of the jail.

I left the lower level and headed to the third-floor cell pod known for housing sexual offenders—male sexual offenders who were convicted of sex crimes against women and children.

A fellow investigator and I—both of us loving mothers of amazing daughters—proceeded to conduct an EVP session to try to push one of the possible rapists held here to make himself known.

The pod consisted of two floors, with six jail cells on each level. During the jail's thirty years of operation, two prisoners had committed suicide in this pod—one on the upper level and one on the lower level.

As we were speaking aloud to any spirits who might be lingering in the area, we began to hear a strange clicking sound. It was the sound of something tapping on metal, and it was coming from the metal table next to the one we were sitting at together.

As soon as we both acknowledged the sound, it stopped.

I asked that if someone had been tapping at the metal table next to me, could they please make the sound again.

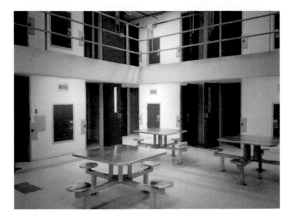

Left: One of the several common areas inside the Gloucester County Jail in Woodbury. *Jersey Unique Minds Paranormal Society*.

Below: The former Gloucester County Jail, now the county Justice Department, seems to have a few prisoners who haven't yet been released. *Author photo*.

It only took about ten seconds for the sound to begin once again, telling me that what I was hearing could definitely be one of the two inmates who had taken their lives in the pod where I was sitting.

While I heard that tapping sound with my own ears, some sounds and voices can't be heard with the naked ear. Many times during an investigation, we don't hear the noises or voices around us until we listen to hours of audio recordings or watch tons of video footage shot during the session.

With the jail's short but horrific history, plagued by death and sadness, it seems there was more energy left behind than we had the opportunity to

A security door inside the Gloucester County Jail in Woodbury. *Jersey Unique Minds Paranormal Society.*

experience in real time. An audio recorder that was set up in a cell pod on the second level picked up a strange breath or a whisper, followed by a distinct laugh, almost like someone was laughing at our attempts to communicate with any spirits who were still lingering in the prison.

Later, in a neighboring cell pod on the same level, a male voice saying "Hey" was caught on an audio recorder, followed by what sounded like a female moaning, which doesn't make sense because females were not held in that section of the Gloucester County Jail.

At around 2:00 a.m., an inaudible whisper was captured in the lower-level cell where the prisoner overdosed, and another audio recorder picked up what sounded like a phantom voice mocking a male investigator who was talking about the investigation. Around the same time, an EVP of a voice saying, "Ridiculous," was recorded on the lower level. With responses like that, it seems as if the spirits who haven't left the jail didn't think much of us conducting an investigation to try to prove they were there.

Possibly the most interesting EVP captured during the jail investigation occurred when the corrections officer who manned the glass control room was talking about the cooks who had worked at the jail in the past. While the guard was talking about the kitchen staff, the audio recorder picked up what sounds like a female voice saying what sounds like "Time to eat" or something about "eating." The nearest female to that recorder was three levels down in the booking area of the jail.

The jail is still standing but hasn't had a prisoner incarcerated within its walls since 2013—at least none that can be seen with the naked eye.

3

THERE'S MORE TO OLDE STONE HOUSE VILLAGE THAN HISTORIC BUILDINGS

OLDE STONE HOUSE VILLAGE, WASHINGTON TOWNSHIP

There are people in this world who are more sensitive to the spirit realm than others. Some people get chills when they are in the presence of a paranormal entity, while others may be able to see an apparition.

On the other hand, there are those who can walk into a room filled with ghosts and not have a clue that there are spirits present. There are those who don't normally have any kind of physical reaction to the paranormal but secretly wish they had a gift similar to those who are sensitive.

I fit into that latter category.

Once in a great while, when wandering through an allegedly haunted building, I'll get a creepy feeling in my gut, but I usually go through entire investigations without feeling a thing. Sometimes, I later discover—while listening to audio recordings from an investigation—that someone was indeed nearby and trying to communicate with me, but I had no idea, so, of course, I didn't react at the time. That's when I feel bad because the spirit most likely felt ignored.

I'm sorry, friendly spirits.

So, because I'm not normally sensitive to the paranormal, I never knew what it was like to get those strange feelings that I've seen other people get when in the presence of a ghost. Therefore, I was always envious of those who could pick up on spirit activity just by walking into a room—that is,

until I had my first experience with "the feels," as I call it, at Olde Stone House Village in Washington Township, Gloucester County.

Olde Stone House Village is the original location of the historic attraction's namesake—the Olde Stone House—a large brick home that dates back to the 1730s.

The large stone house sat at its Egg Harbor Road location alone for many years until the township decided to bring in some neighbors and create a park.

In the 1980s, four other historic buildings from the area were moved to the land surrounding the Olde Stone House to create the Olde Stone House Village. These buildings include the Quay House, the Blackwood Train Station, Turnersville Post Office and the Bunker Hill Presbyterian Church.

The Olde Stone House is built from locally quarried limestone, which is a well-known conductor of paranormal energy.

The Quay farmhouse was built for Thomas Cocks Crees and his wife in 1825 by John Turner, the founder of Turnersville, and was constructed in traditional tongue and groove fashion, held together by wooden pegs and handmade nails. The house was later purchased by Charles Quay Sr. and his wife, and it was moved to its current location in 1988.

The Olde Stone House and namesake of the Olde Stone House Village in Washington Township. *Author photo.*

The Turnersville Post Office was built in 1864 and originally stood on Black Horse Pike near County House Road. The building served as a post office until 1903, when it was converted to a courtroom. Its first move was to the Quay Estate in 1971, but it was moved again to the village in 1988.

The Blackwood Railroad Station was built in 1891 and was originally located on Church Road near Blackwood Lake. This building was also located on the Quay Estate for twenty-three years before being moved to the village in 1988.

And finally, the Bunker Hill Presbyterian Church was originally the Bunker Hill Schoolhouse. Church services were first held in the building in 1849 and continued to be conducted there until a new church was built in 1869. The original church building was moved to the village in 1986 and contains the original pews, pulpit and chairs.

It was there, in the Bunker Hill Presbyterian Church, where I experienced my first bout of being physically affected by something I could not see or hear.

I visited the village for the first time in March 2014 with a group of paranormal investigators and explored each of the buildings located at the historic attraction.

Each of the buildings is beautiful and interesting in its own way. But I had a special interest in one particular spot due to some information I learned before I arrived.

Prior to visiting the Olde Stone House Village, I heard claims that people would see and hear a young girl running and playing inside and around the outside of the church building. She has been heard several times during community events at the village and has even been seen a few times in recent years.

There were also reports of an angry elderly couple, who were often spotted in one of the back pews of the church. Visitors have reported hearing sounds of quarreling, and they also get an uneasy feeling while sitting in the back pew on the right side of the church.

When I entered the church, it was bright and open and didn't seem angry at all. Two other investigators and I were walking around the inside of the chapel, taking in the historic beauty of the simple parish, when I decided to go sit in the elderly couple's pew.

I sat down quietly and placed a K-2 meter on the bench next to me. It was quite relaxing to just sit quietly in the church pew and take in the historic atmosphere. But while I was sitting in that back pew, something began to physically overwhelm me.

The Bunker Hill Presbyterian Church at Olde Stone House Village where an "angry elderly couple" have been spotted in a back pew. *Author photo.*

The strange feelings started in my head. It began as a slight pressure on top of my head that was barely noticeable, but then it quickly grew into a full-blown headache. The ache didn't feel like a normal headache. Instead of pain, it was more of a feeling of pressure—like my head was in a vise. I started to write it off as just being tired and a bit hungry, until I began to get a strange, empty, hole-like feeling in my stomach. And then the empty feeling quickly turned to nausea.

The K-2 meter—which reads fluctuations in electromagnetic fields—never responded to any of the activity that I felt like should be going on around me, but there was undoubtedly something happening in that pew.

The longer I sat there, the worse I felt.

After what seemed like ten minutes, but was most likely only a few, I felt like I needed to get up and get away from that back pew. I gathered my belongings, stood up and gingerly walked out of the pew. I joined the other two investigators at the front of the church and explained to them what had happened to me in that mysterious back pew.

I sat down in one of the front pews while I spoke, and within just a few minutes, I felt fine—no headache, no nausea, no pain. I was back to normal.

I suddenly realized that I had just had my first experience with "the feels." And it was also at that moment when I finally realized and admitted that I was somewhat relieved that I didn't have the power of sensitivity that some people have. I would not be able to deal with feeling like that every time I encountered the paranormal. Being an investigator, encountering a spirit can happen quite often.

What I felt was not a fun feeling at all. It wasn't like being in touch with a spirit. It was like coming down with the flu in three and a half minutes. Honestly, I didn't like it at all.

A possible explanation for the sick feelings that came over me while sitting in the pew where the angry elderly couple has been witnessed has to do with energy.

Spirits try to draw energy from anything in a room that they possibly can. Whether they are trying to get someone's attention or communicate with a person, spirits sometimes try to draw energy from electronics, batteries and

This small cemetery is located beside the Bunker Hill Presbyterian Church at Olde Stone House Village. *Author photo.*

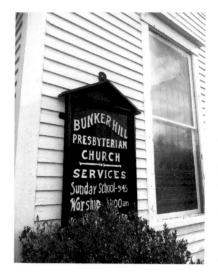

The Bunker Hill Presbyterian Church at Olde Stone House Village where an "angry elderly couple" have been spotted in a back pew. *Author photo.*

even people. If a nearby spirit is trying to take energy from a living person, it doesn't matter if that person is sensitive, a psychic or a medium, the person will most likely feel the effects.

There are, no doubt, times when people feel the way I felt and don't realize that what is actually happening is paranormal. But now that I have felt what being sensitive really feels like, I'm going to try to avoid feeling like that again at all costs.

After the experience that I had in the back pew of the church, a fellow investigator wanted to see if the same feelings would overcome him in the same way they did me if he visited the same pew.

He entered the church and took his place in the pew where I had been sitting previously, and after only a few minutes, he started feeling what he described as an electrical charge. It started at the top of his head, as it did with me, and worked its way down his neck and shoulders.

The investigator told the spirit that he wasn't afraid and that messing with him physically would not scare him away. After he confronted the spirit, he said the feeling began to dissipate and eventually disappeared altogether, leaving the man in peace.

Having a negative reaction to an interaction with a spirit can sometimes lead people to believe the spirit they came in contact with is malicious and dangerous.

However, even if it seems like a spirit is malicious because its presence causes uncomfortable feelings similar to the ones I experienced in the church, the feelings could just be caused by their energy.

Because I felt nauseated and my head felt like it was being tightly squeezed, I could have easily assumed that the spirits were evil. But that's not always the case. Just like a stove, if you burn yourself on the burner, it's not because the stove is trying to scare you or tell you to get away. The burner is hot, and you touched it. That's just what it does.

4

SPIRITS ON THE MENU AT BLUEPLATE

MULLICA HILL

Mullica Hill, a quaint community that's part of Harrison Township in Gloucester County, was settled in the early 1700s, at the time of the Revolutionary War. The entire village is listed in the National Register of Historic Places, making it rich in history and a prime area for ghost stories.

Boutiques, eateries and antique shops sit among historic churches and landmarks up and down Main Street, making Mullica Hill a great destination for a day trip—or a night trip if you're interested in trying to see a ghost.

Blueplate restaurant, located on South Main Street and owned by Chef James Malaby for more than ten years, is housed in one of Mullica Hill's most historic buildings.

Malaby said the building was constructed in the late 1800s and was only a portion of what it is today when it was originally built. The main dining room, the basement below it and an apartment above the dining room make up the original section of the building. That original structure has been added onto twice during its nearly two-hundred-year history.

"It has switched owners and configurations a lot over the years," Malaby said.

While it has always been Malaby's dream to own a restaurant, he didn't realize that when he invested in the Blueplate building he may have also inherited a few permanent patrons.

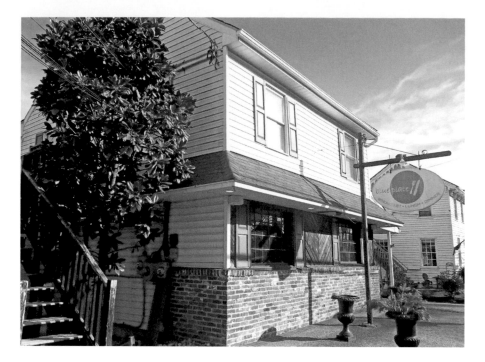

The original section of the Blueplate restaurant in Mullica Hill dates back to the 1800s. *Author photo.*

Even though Malaby has had a few experiences at Blueplate himself, and a waitress who has worked at the location for longer than Malaby has owned it feels it's haunted, the chef never really thought seriously about his resident ghosts until one October.

"Mullica Hill's Haunted Ghost Tours meet here in October, so one night we just started talking about things we've seen and heard around here," Malaby said. "There are two sisters who have worked here for more than twenty years. One says we're crazy; the other says, 'Oh yeah, it's haunted.'"

So, Malaby decided to contact a paranormal research team to come in and investigate the building in the hopes of confirming or dismissing the possibility of a haunting at Blueplate. Luckily, I was invited to join the investigators at Blueplate, and it proved to be a very interesting evening.

The claims of paranormal activity at the restaurant led me to believe there could be both residual and intelligent hauntings present.

"Sometimes I can be sitting in my office in the basement with the door cracked open and see someone walk by," Malaby said, mentioning his office is on the outside wall of the basement, meaning for someone to

walk by, they would have to be either coming into the basement or leaving the basement to go outside. "Also, a lot of employees have said they see someone out of the corner of their eye in the kitchen near the pots and pans area."

Malaby said he sometimes hears footsteps above him while he is in his basement office. He said he can be the only person in the building and he will still hear someone walking across the floor above him.

One evening a few years ago, Malaby wasn't even in the building when the spirits decided to make some noise and cause some trouble.

"It was about two or three in the morning, and the people who lived upstairs called the police and said the radio was blaring in the restaurant, but there was no one here at that time," he said. "When the cops got here, there was no music playing."

One evening, Malaby received an e-mail from a longtime customer asking him if there was a fireplace in the basement of the restaurant. Malaby told him there was indeed an old fireplace in the original section of the basement.

"He said he would be by early the next morning because he had to see it," Malaby said.

This man, who was born and raised in Mullica Hill, heard there was an old building on Main Street with a fireplace in the basement where the town fathers would hold secret meetings back in the early 1700s.

While it's not clear if Blueplate is the exact building the man was referring to, it does fit all the criteria he was describing and could possibly be the location of the secret town meetings he was discussing with Malaby.

On April 21, 2013, I joined three investigators at Blueplate, and we set up two infrared night-vision cameras in the basement, one in the kitchen and one in the dining room. Each camera was accompanied by an audio recorder in order to catch audio evidence to accompany any video evidence that might be recorded by the cameras.

Once everything was in place, it was lights out and time to investigate.

One investigator took the first shift at command to keep an eye on the video monitor, while I descended the basement stairs, accompanied by two investigators, and headed straight for the strange fireplace.

Almost immediately, we were getting inconsistent K-2 meter readings and strange hits on the meter in random areas of the basement.

The investigator at command had one walkie-talkie, and we had its partner in the basement. As we noticed the K-2 reacting to electromagnetic energy in the air, the walkie-talkies started acting strange.

Suddenly, one of the K-2 meters spiked, causing every light on the device to illuminate. Seconds later, the investigator at base called down to us via the walkie.

He said he saw the K-2 meter flashing while he was watching us on the video monitor, and as the meter was reacting, he saw a slow-moving light anomaly travel around where we were standing and then disappear into the K-2 meter. That's when the K-2 meter started to flash.

The orb could have been dust or a bug based on its flight pattern, but the fact that the K-2 began flashing just as the anomaly seemed to fly into it makes it a possibility that what we witnessed was paranormal.

While we were still in the basement and the walkie-talkies were still on and working, the one we had with us in the basement made a clicking sound like someone was trying to call us. Even though the paranormal team has several walkie-talkies, we were only using two that night.

At one point while we were in the basement, the walkie-talkie mic opened like someone was trying to contact us more than twenty times, but no one ever said a word. Once it stopped clicking, we broke through to the investigator who was upstairs at base and asked if he was trying to contact us. He said he hadn't touched the radio, and his had been quiet the whole time.

The original section of the Blueplate restaurant in Mullica Hill dates back to the 1800s. *Author photo.*

The radio wasn't the only piece of equipment that reacted strangely that night at Blueplate.

Normally, during an investigation, I use a digital voice recorder that records audio footage the entire evening. I don't hear what it picked up until I get the recorder home, upload the footage to my laptop and then listen to the recording using headphones.

But during this investigation, we had a real-time audio recorder—one that will record while you listen to what is being recorded in real time. In other words, if I picked up an EVP during the investigation, I would hear it right then and there and be able to communicate with whomever may be present. The device worked great the entire investigation, even though I only heard one possible EVP.

However, while I was reviewing the audio evidence from a regular digital audio recorder, the sound was going in and out and sometimes sounded like it was being held under water.

Strange.

That next October, for the Mullica Hill Ghost Walk, Malaby had night-vision cameras placed in the basement with a feed to a video monitor that was placed outside on the back deck behind the restaurant, where participants gathered before the tour.

Many of the guests enjoyed watching the monitors, and some thought they saw some strange activity in the basement of Blueplate restaurant.

Speaking of the ghost walk, I had a very interesting experience one year while leading a group of guests up and down Main Street from one haunted house to another.

We took the tour group to St. Stephen's Episcopal Church—a quaint parish with bright red double doors at the main entrance. We were greeted by the church deacon, who welcomed us into the cozy 1832 church.

The guests were seated quietly in the wooden pews throughout the church as the deacon began telling stories about the history of the church. As she began telling the story of a young boy who was hit by a car and killed sometime in the early 1970s, the main lights in the building went out, leaving the tourist congregation in complete darkness.

Even though most of the ghost walking tour was based on real stories and history, some of the homes and businesses involved added a bit of dramatics by including spooky effects or people dressed up in costumes to scare the participants.

At first, I figured the deacon had an assistant hiding somewhere who flipped the light switch to give us all a start, but her sincere reaction made

Construction on St. Stephen's Episcopal Church in Mullica Hill was completed in 1853. *Author photos*.

me wonder. Obviously startled, the deacon stood quietly at the pulpit for a few moments before walking over to the right side of the front of the church to turn the dimmer switch back up, once again illuminating the pews and the visitors sitting in them.

With a nervous giggle, she briefly explained that the lights had never gone out in the church like that before that night—at least to the best of her knowledge. It was apparent that she was still confused about what had just occurred, but she shook off the unexplainable incident and continued telling the story of the little boy.

The young boy's funeral was held right there inside the church where we were all sitting at the time. During the service, two of the deceased's friends began to giggle while looking up toward the balcony in the back of the church. Since the two children had just lost their friend, the mourners surrounding them wondered why in the world they would be laughing while attending their friend's ceremony.

When asked, the two kids said they were giggling out of happiness because there were two angels in the upper corner of the church, near the ceiling over the balcony.

Just as everyone looked up into that back corner—because, of course, when you're told there were once angels floating there, you want to take a chance on seeing them yourself—the lights went out once again.

Being the second time they were left in the dark, the audience was understandably startled and sat still and quiet while the deacon was once again forced to turn the dimmer switch back up to bring the light back to the darkened room.

Again, she smiled and tried to dismiss the incident to some naturally occurring situation, but I knew something strange was happening there in that tiny church.

After the presentation, I approached the deacon to ask her what was happening with the lights in the church. She told me having the lights turn off in the middle of a visit from a tour group or a Sunday morning sermon was not a normal occurrence.

I examined the dimmer switch she had turned both times to get the lights to come back on, and it was, indeed, a common dimmer switch that had to be turned one way to turn the lights off and the other way to turn them back on. So, because she had to literally turn the switch to get the lights to come back on, someone or something had to have turned it the opposite way to turn them off.

This small cemetery is located behind the St. Stephen's Episcopal Church in Mullica Hill. *Author photo.*

The deacon was surprised by the lights being manipulated with a church full of guests, but she wasn't particularly frightened. She said that there have been many strange experiences in the nearly two-hundred-year-old church and in the small cemetery located directly behind the parish.

There is a legend about the St. Stephen's Episcopal Church cemetery that involves the ghost of a young woman whose body was allegedly exhumed from her original burial site and reburied there. Perhaps she is suffering from unrest because she was moved and enjoys frequenting the church and playing pranks. Or perhaps the little boys' angels are mischievous and wanted to make the guests aware that they are still hanging around.

Whatever the case, the pretty little church on Main Street in Mullica Hill seems to have some invisible parishioners in addition to its loyal congregation.

SPIRITS OF
SALEM COUNTY

5

BED, BREAKFAST AND BUMPS IN THE NIGHT

BARRETT'S PLANTATION HOUSE BED AND BREAKFAST, MANNINGTON TOWNSHIP

There are certain haunted locations that I've investigated that hold a special place in my heart. One of those places is Barrett's Plantation House Bed and Breakfast.

The beautiful and stately colonial home sits on what was once the main thoroughfare in Mannington, leading from Quinton into Salem City. During the Revolutionary War, soldiers marched that path into Quinton, where the skirmish at Quinton Bridge took the lives of nearly two hundred men and their horses.

Barrett's Plantation House Bed and Breakfast is a cozy and quaint inn located in the small countryside town of Mannington Township in Salem County.

Originally a farmhouse, the oldest portion of the Barrett's Plantation House was built in 1735. This nearly three-hundred-year-old structure is the front section of the home, which can be seen from Old Kings Highway. The parlor, a formal dining room and the gentlemen's sitting room are located on the first floor, while two guest rooms—the Dickinson Suite and the Morris Suite—can be found on the second floor. The garret, or attic, is located on the third floor and serves as another guest room.

In the 1800s, a kitchen, complete with a large fireplace that was used for cooking, was built onto the back of the original structure. Today, that area of

the home serves as another sitting room and is a favorite spot for both guests and the owners of the inn—Gaynel and Craig Schneeman—to sit and relax in front of the beautiful fireplace.

The final addition was built onto the rear of the home in 1991. This portion of the home contains a modern kitchen on the main floor and the owners' suite on the second floor.

The two suites on the second floor and the third-floor garret are available for guests to rent for an overnight stay or a relaxing weekend away. However, anyone who spends the night at Barrett's Plantation might end up sharing their accommodations with an invisible, but permanent, resident.

The Schneemans first visited Barrett's Plantation in the 1970s when they were exploring Salem County on a springtime house tour. Gaynel later said she couldn't get the house out of her mind, and apparently, the universe had plans for the couple and the historic home.

Several years later, she happened upon an advertisement for Barrett's Plantation in a real estate book and knew she and her husband had to go back and see it at least one more time.

Barrett's Plantation House sits on Old Kings Highway, which was the main thoroughfare in Mannington. *Author photo.*

The dining room in Barrett's Plantation House in Mannington. *Author photo.*

"Once we got inside, we knew we had been there before," Gaynel said of the house that would soon be theirs.

The Schneemans were living in a restored historic home in Mullica Hill at the time and hadn't even thought about putting their home up for sale. However, they knew they wanted to buy Barrett's.

The very next day, they received a letter in the mail from a woman who needed a bigger house and was interested in their Mullica Hill home. The couple realized "things just don't happen like that" and knew that what was happening was meant to be.

The Schneemans sold their Mullica Hill home to the woman who had reached out to them about buying it—even though it wasn't for sale—and purchased the Barrett's Plantation House for themselves.

Since that time, the couple has worked diligently and done much renovating and remodeling to bring the colonial masterpiece back to its original beauty. At the same time, they began researching the deep history surrounding the house and property.

The original house was built in 1735 by Thomas Dickinson Sr. and stayed in his family for several years.

The house changed hands several times, but the owner who held the deed for the longest, most consistent period of time was a tough, straight shooter named Kate Carmody. Kate lived in the home from 1900 to 1937 and died at Barrett's Plantation. Gaynel said Kate was very proud of the home, and she would not be surprised if the former owner was still there.

In their many years working on the house, even with all the renovations that can sometimes stir up paranormal activity, the Schneemans never really witnessed anything out of the ordinary.

However, after Barrett's Plantation House Bed and Breakfast opened to the public in 2011, many visitors, family members, friends and bed-and-breakfast guests began inquiring about strange occurrences they witnessed on the property.

The most common sighting is that of a small boy, around seven years old, that several guests have mistaken for the Schneemans' grandson.

Gaynel recalled one particular occasion when a couple who was staying at the bed-and-breakfast approached her in the morning and asked her if the boy they had seen playing on the porch the previous evening was her grandson.

"My grandson wasn't visiting," she recalled.

There were no young boys visiting the inn at the time.

Another guest once saw the outline of a person looking out the third-floor garret window. The window sits low on the wall, only a foot or so off the floor, due to the peaked roof. The guest described the figure as short and thought maybe it was a child. However, there was no one up in the garret at the time of the sighting—no children or adults.

After years of hearing reports of a small boy being seen in their bed-and-breakfast, Gaynel and Craig began to call the spirit "Pumpkin." Even though Gaynel has yet to see him, she speaks to him often and assures the youngster that he is more than welcome to stay and be a part of their family.

While the Schneemans don't normally advertise the unseen guests who still inhabit the bed-and-breakfast, they don't mind sharing their home with the spirits.

"I never tell the guests about the activity," Gaynel said. "But if they ask when they check in, I tell them we'll discuss it the next morning."

And many morning discussions concerning phantom footsteps, disembodied voices or even ghostly sightings have taken place during the early hours in the dining room over coffee at the inn.

Guests have reported hearing, feeling and seeing unexplainable things at the bed-and-breakfast, and many of those guests keep coming back. Gaynel said they enjoy the inn so much that they don't mind a little spirited activity.

The Dickinson Suite, one of the guest rooms at Barrett's Plantation House in Mannington. *Author photo.*

My first visit to Barrett's Plantation Bed and Breakfast was in February 2013 to see if I could experience any of its ghostly beauty for myself. Expecting a kind of creepy, old, dark and spooky house, I was shocked with what I found.

As soon as I walked through the front door, I felt at home. The inn's historic charm and warmth radiated from every corner of the home. I had no idea how many adventures awaited me and how many experiences I would have at the bed-and-breakfast over the next few years.

After that first visit, Barrett's became one of my favorite locations to investigate. Just as athletes have their favorite stadiums to play in and rock stars are partial to certain venues, paranormal investigators have their favorite haunts.

During my first investigation at Barrett's, I joined JUMPS—Jersey Unique Minds Paranormal Society—to try to capture some evidence of Pumpkin and any other spirits who may be lingering at the inn. Another investigator and I experimented with what I call the flashlight game—a trick I picked up from watching paranormal investigation shows on television for more than

ten years. Given the fact that a young boy had been seen up in the garret, I decided to set up a flashlight on the bed that could be manipulated by any spirits that may be up there with me.

THE FLASHLIGHT GAME

Using a twist-on flashlight, I turned the lighted end toward the "on" position just slightly, so that the light was just barely off. Next, I placed the flashlight on a board on the bed.

With the lights in the bedroom turned off, we walked out into the sitting room just off the bedroom and proceeded to speak to any spirits who might be nearby.

"I just put my flashlight on the bed in that room," I said aloud to no one in particular. "It's off right now, but if you just touch the end that lights up, it will come on."

Getting a paranormal reaction during an investigation can sometimes take quite some time, if anything happens at all. I have spent many hours in dark rooms and left without having seen or heard anything at all the entire night.

However, it only took a few minutes after explaining how to operate the flashlight for it to slowly flicker to life. As if someone was lightly touching the power end of the torch, the bulb flashed on and off quickly a few times and finally shone brightly through the dark room.

After my shock subsided, I realized the heater had clicked on at the same time that the light came to life.

The first goal in paranormal investigating is debunking any evidence that is not paranormal. Many strange happenings that appear to have no explanation can be disproved through a natural circumstance.

The flashlight was sitting on a thick wooden board placed on top of the comforter on the double bed. My fellow investigator examined the setup to see if any vibration from the active heater could be affecting the flashlight, and we confidently ascertained that the device had not been disturbed by the heater.

However, a flashlight turning on one time does not prove the presence of a ghost.

Paranormal investigators look for several pieces of evidence—kind of like pieces of a puzzle—to determine whether the activity is paranormal or natural.

Guests can also stay in the third-floor garret at Barrett's Plantation House in Mannington. *Author photo.*

While I was checking on the viability of the flashlight, I had a personal experience that would help to verify the suspected paranormal activity.

As I stood in the garret, keeping an eye on the flashlight, I thought I saw something flash out of the corner of my eye. At the same time, I felt like there was some kind of presence nearby. I couldn't explain exactly what I was experiencing because both the movement and feeling were so faint, I wasn't completely convinced anything was happening at all. So, in keeping with the routine of paranormal investigation, I decided to do a full-on EVP session.

The goal of an EVP session is to capture voices and sounds from spirits that cannot be heard with the human ear by using a digital voice recorder.

"If you're here, touch my hand," I said, stretching my arm out toward the area where I thought I saw the strange light anomaly. "It's okay, you can touch me."

I stood waiting, arm outstretched into the darkness, hoping that I would feel the pressure of another hand in mine or fingers embracing my arm. But instead of being touched by something I couldn't see, the flashlight's

bright beam came to life once again. The heater was completely off this time around, and even though I hadn't asked for the light to be turned on, it shone brightly from the board on the bed.

Despite the fact that my request to be touched hadn't come to fruition, my entire body broke out in chills, and the tiny hairs on my arms and back of my neck stood up straight. I realized that, perhaps, the spirit wasn't strong enough to actually hold my hand but could manipulate the flashlight with its energy. If that was the case, we could use the light as a means of communication.

I asked whomever was present to please turn the flashlight off again. A few seconds passed before the light flickered and died once more.

I began asking questions, asking the spirit to use the flashlight to communicate with me. The exchange went on for about ten minutes before the flashlight finally went off for the last time.

After the investigation was completed and I was listening to the audio recordings of EVPs captured during the flashlight game, I discovered I had captured another piece of the evidence puzzle.

The sitting area in the third-floor garret at Barrett's Plantation House in Mannington. *Author photo.*

I had asked a question pertaining to the spirit's identity in life, and the recorder picked up a clear response.

I asked, "Were you a servant in this house?"

The recorder picked up a child's voice clearly saying "No."

Could the child's voice belong to the spirit that had been seen so many times prior to that evening? Could the recorder have picked up the voice of Pumpkin? Perhaps, but after several investigations and a good amount of solid evidence, it's been determined that Pumpkin is most likely not the only spirit who still resides at Barrett's Plantation House.

THE GENTLEMEN'S SITTING ROOM

I returned to investigate Barrett's for the second time nine months after my first visit.

My experience during the second investigation was very different from the one I had communicating with a spirit using a flashlight in the garret.

This time, I was visiting Barrett's Plantation as part of the Historic Ghost Tour of Salem County. The bed-and-breakfast was the grand finale.

After a long night of guiding thirty-plus tourists through several stops around the county, my feet were ready for a break. I noticed that everyone was either up on the second and third floors or outside by the bonfire. I decided to take advantage of the quiet time and headed into the cozy first-floor room that once served as the gentlemen's sitting room. This room has a fireplace, two windows, two shallow closets and a few fluffy armchairs.

The lights were dimmed and the candles were lit, filling the room with a warm, welcoming glow. I chose the armchair to the right of an antique table in the center of the room and settled in. The quiet was relaxing and the atmosphere pleasant—that is, until I was reminded that this particular area of the home was, at one time, for the men only.

As I sat in the small room unwinding in the comfortable chair, I had the wits scared out of me by a loud and lengthy scratching sound that suddenly erupted in the corner of the room, behind the chair where I was sitting. The startling sound reminded me of the noise a dog's nails make on a door when he wants to go outside or come back inside. However, there were no dogs on the property, and the sound definitely came from inside the room.

The commotion caused me to break character in a big way, and apparently, I forgot why I was there. My natural instincts took over, and I jumped up

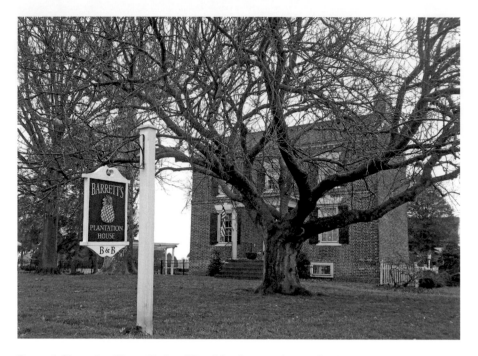

Barrett's Plantation House Bed and Breakfast is a cozy inn perfect for an overnight stay or weekend getaway, Mannington. *Author photo*.

out of the chair. I started to run out of the room—and probably would have gone right out the front door if I had gotten that far.

But I soon remembered that I was indeed a paranormal investigator, and these kinds of incidents were the kind that I longed for when exploring a supposedly haunted location like Barrett's.

So, with my proverbial tail between my legs, I walked back into the room, past the chair and into the corner where the mysterious scratching sound had come from.

"Hello? Is there someone here with me?" I asked.

Getting no immediate response, I set a K-2 meter on the table in the middle of the room and sat back down in the same chair I had been sitting in when the scratching sound first startled me. I continued asking questions, conducting an EVP session in the hopes of connecting with whatever it was that seemed to be trying to get me out of the room, but never heard the scratching sound again.

The K-2 meter did react a few times during the EVP session, but the activity wasn't consistent enough to use as evidence.

Even though I have no audio or video proof of the crazy scratching sound that caused me to flee from the gentlemen's sitting room at Barrett's Plantation House, I know what I heard, and I know the sound was out of place in that tiny, cozy room.

Party for Pumpkin

The Dickinson Suite at Barrett's Plantation House Bed and Breakfast in Mannington. *Author photo.*

Gaynel says that Pumpkin, the spirit that is believed to be a young boy, enjoys when company visits the inn.

One Christmas, the Schneemans were hosting a holiday get-together and found out after the party that Pumpkin had been in attendance.

"My friend's husband was sitting in the back sitting room relaxing," she said, noting that the man rode a Harley Davidson motorcycle and didn't believe in the paranormal. "He said he saw a little boy come down the staircase, cross in front of the fireplace and then disappear."

Hearing the news that Pumpkin had made an appearance during the holiday party wasn't surprising to Gaynel.

A psychic who once stayed at the bed-and-breakfast told her Pumpkin enjoys when there are a lot of people at the inn.

I've investigated Barrett's Plantation House Bed and Breakfast several times now, and I experience some kind of paranormal activity every time. I've heard EVPs of a child's voice, a male voice—even a woman's voice—and have seen and heard other unexplained activity that makes me consider the inn a hotbed of paranormal activity. Barrett's is definitely one of my very favorite haunted spots, not to mention a warm and welcoming historic home with lovely owners who are always interested in sharing the house's history and hearing about the evidence gathered during each investigation.

Barrett's is a great place for a weekend getaway—one that could include an encounter with the other side.

6

SALEM CITY'S SPIRITED HISTORY

SALEM CITY

A city full of history sits in the seat of Salem County. Salem City was founded in 1675 by John Fenwick after a dispute that had to be settled by William Penn himself. With more than 340 years of rich history, there are hundreds of interesting, bizarre and even scary stories that surround the not-even-three-square-miles of land situated on the Salem River.

In the 1920s, one of New Jersey's most infamous legends made a visit to Salem and caused quite a ruckus in town.

It was 1927, and a taxi driver was changing a tire late one night on the side of the road. Allegedly, the taxi began bouncing up and down violently while he was attempting to replace the flat tire with a new one.

Reports say the driver looked up and saw a large, hairy, winged creature pounding on the roof of his taxi. The man believed he was peering into the eyes of the Jersey Devil itself.

Fearing for his life, he climbed back into the car and drove away, leaving his jack and flat tire lying in the street. He allegedly drove to the police station, where he told an officer that a winged creature was pounding on the roof of his cab, and he believed it to be the Jersey Devil.

While this story is based on one man's personal experience, there are many ghost stories associated with historic buildings in Salem that several eyewitnesses will attest to.

Johnson Hall

Colonel Robert Gibbon Johnson, a farmer, historian, horticulturalist, judge, soldier and statesman, built Johnson Hall—a three-story Federal-style brick home—in 1806 for his wife, Hannah. The house was handed down to their daughter, Anna.

Eventually, the county purchased historic Johnson Hall and moved to its current location on Market Street.

In January 2011, the county chamber of commerce moved its offices into the historic building. Almost immediately, employees began reporting strange activity.

Jennifer Jones, executive director of the Salem County Chamber of Commerce, is one of several county employees who has witnessed some strange activity in Salem's Johnson Hall.

"I was always the first one there," Jones said. "I opened up, turned off the alarm, et cetera. Some days, one computer or the other would be on. And we always shut everything down at night."

There were offices in each room on the third floor, and the door to each room has a lock that automatically engages when the door shuts.

"I was taking boxes upstairs to the room we were using as a storage closet," Jones recalled. "Every time I went up to the third floor, some of the doors would swing open. I thought it was me walking on the old, crooked floors, until my last load, when the door to the storage room had shut tight and locked itself."

A few days after her incident, Jones was walking a chamber of commerce member through the building, and the two had an interesting conversation that led to a startling experience.

"When we went up to the third floor and were standing in the doorway to one of the rooms, he asked me if the building had ghosts," Jones recalled. "I laughed and told him about the storeroom door closing and locking."

Suddenly, the door to the room that the pair were standing in began to move slowly and finally shut tight right in front of them.

When Jones worked in Johnson Hall, her office was on the first floor. The second floor is where the master bedroom was once located.

"The room directly above us was once the master bedroom," Jones said. "That room was locked, and we had no key. There is only one entrance to the building, which is the front door. But we used to hear what sounded like someone walking on a wooden floor in high heels above us."

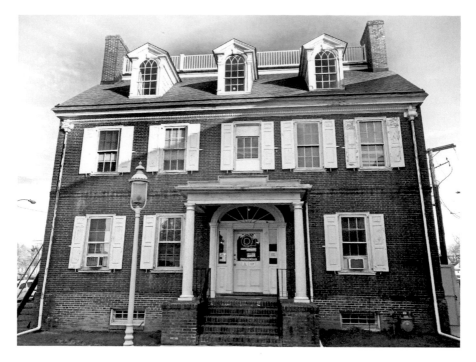

Johnson Hall in Salem City is said to be the home of several spirits. *Author photos.*

Finally, the key was located and the door to the master bedroom was opened.

"There was carpet on the floor," Jones said.

That was a surprise.

As Jones said previously, she was often the first one to arrive at Johnson Hall in the morning and was sometimes in the building alone for a while.

"One morning I came in and shut off the alarm located in the Grand Hall just inside the front door," she said. "I swear I startled something because I heard a sharp intake of breath from the back hall, then what sounded like someone running up the stairs to the third floor. The footsteps even changed rhythm on the landing."

Not long after the chamber of commerce offices were moved into the historic building, work began on the first floor to bring the building up to code with the Americans with Disabilities Act regulations.

"The county did renovations to the downstairs to add a handicapped elevator and handicapped bathroom for the tourist information center," Jones said. "The bathroom has a motion sensor hand dryer. It used to go off by itself."

She said they called in the building and grounds crew to check the machine for malfunctions, but there was nothing wrong with the dryer.

"They said it was fine," Jones said. "It could not be operated without motion."

Jones not only heard strange things when she worked at Johnson Hall but also saw a few apparitions.

One day, she was working at her desk when a co-worker left the building to go outside and retrieve the mail.

"Just after she went outside, someone rang the doorbell," Jones said. "I got up to answer it and could see someone standing outside the door in a fedora and raincoat. By the time I got from my desk to the front door, no one was there."

While that incident seems to have been with a male, Jones had an experience with a female on another day at Johnson Hall.

"At the end of the day, the county maintenance people would come into Johnson Hall," Jones said. "They met in one of the rooms upstairs before starting work."

One afternoon, a member of the chamber of commerce stopped by to see Jones and was sitting in a chair across from her desk.

"I heard the front door open," Jones remembered. "Out of the corner of my eye, I saw someone on the stairs, and I could hear what sounded like

material rustling. I turned to greet the person, but what I saw looked like a white figure wearing a gauzy white dress."

Jones knew this woman was definitely not a part of the county's maintenance department.

In the beginning, Jones and her co-workers didn't discuss the strange activity in Johnson Hall very often.

"I had been afraid to say anything because I didn't want people to think I was nuts," she said.

But one day she decided to tell a friend, and he had a suggestion.

"We were telling Eric Pankok about our experiences," she said, noting that Pankok is the owner of the Printers of Salem County and a chamber of commerce member. "He suggested we call in a paranormal team. So, that's what we did."

In March 2011, Jones welcomed investigators Jersey Unique Minds Paranormal Society to Johnson Hall. The team came in with video and audio recorders, K-2 and EMF meters and a curiosity that would soon be satisfied.

During their visit, investigators determined that the doors on the third floor do sometimes move on their own due to the building being slightly uneven, but on a few occasions during the investigation, certain doors swung shut quickly, as if they were being pushed.

As a way of attempting to make contact, one team member decided to give one of the spirits a name. He began addressing the ghost that allegedly causes footsteps in the master bedroom Annali.

Soon after he started talking to Annali, he felt an invisible hand rubbing his hair. After about ten minutes of this interaction, the investigator who was manning base and watching the video monitor radioed to the investigator in the master bedroom and said she had seen a "mass sit down on his lap." The investigator not only felt the hand touching his hair but could also hear what sounded like someone manipulating the metal blinds on the windows in the second-floor bedroom.

Jones joined two investigators in the master bedroom and was witness to one of the investigators being touched. After the three women had been in the master bedroom for about twenty minutes, one investigator reported she had been pinched on her left shoulder close to her neck. She asked her fellow investigator to look at the area, and there was a small lump and red mark on her shoulder where she felt the pinch.

Jones said that while she was in the master bedroom, she felt someone playing with her hair.

The paranormal team captured quite a few EVPs while investigating Johnson Hall, including one in a foreign language.

While on the third floor, an audio recorder picked up a disembodied sentence in German. Translated, the voice was saying either "I am playing, amen" or "I am playing my clarinet."

The team returned to Johnson Hall to conduct two additional investigations, and they recorded more evidence including EVPs each time. From the experiences they had in the historic building, the team determined that there is definitely activity in Johnson Hall.

"I loved Johnson Hall and still miss working there," Jones said. "It's kind of comforting to know that Mrs. Johnson loved the house so much that she decided to stay."

Could the woman Jones saw on the stairs have been Mrs. Hannah Johnson?

THE RICHARD WOODNUTT HOUSE

Traveling down Market Street in Salem City is like taking a step back in time. Some of the homes that stand along this main thoroughfare date back to when the city was first founded in the late 1600s and resemble the stately buildings that give Old City Philadelphia its colonial character.

With saltbox houses, Cape-style homes and large Colonials—in addition to historic and beautiful churches—Market Street offers endless stories of history and hauntings.

The three-story brick Colonial that stands at 29 Market Street developed a reputation for paranormal activity back in the early 1990s when it was purchased and transformed into a bed-and-breakfast.

The Richard Woodnutt House was built in 1750 and was the home of Richard; his wife, Sarah; and their daughters, Grace and Sarah, who both allegedly went through life unmarried, according to *History of Genealogy of Fenwick's Colony, New Jersey* by Thomas Shrouds.

A newspaper article that appeared in the May 6, 1997 issue of Salem's *Today's Sunbeam* said that Sarah was born and raised in the Woodnutt House and lived there until 1889, when she died at age thirty-three.

In 1992, the Woodnutt House was purchased and transformed into a bed-and-breakfast. When guests began checking in, the spirit of Sarah started checking them out.

The first guest to question the owner about unseen guests at the inn was a young male actor who asked if the inn was haunted. After about a half

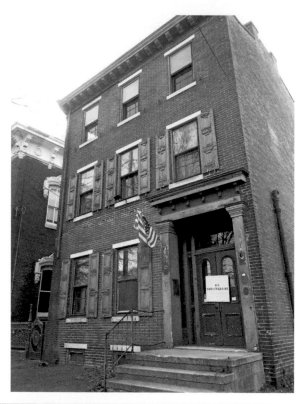

The Richard Woodnutt House in Salem is said to be haunted by a young woman named Sarah. *Author photos.*

dozen guests reported hearing footsteps and having strange experiences such as hearing a knock on the door to their room and answering it to no one, the owner of the inn began to look into the history of the home and quickly started putting together some of the puzzle pieces she was gathering from her tenants.

All of the guests who reported seeing a ghost or hearing unexplained noises throughout the building were males in their late twenties or early thirties.

Some guests reported feeling someone sit on the bed with them or play with their hair.

Sarah Woodnutt died a single woman at thirty-three years old and was never married. Could she be looking for the love of her life even after her own death?

Most of the reported experiences took place in the Sarah Woodnutt Room and second-floor hallway. Footsteps have been heard on the back stairway, in the second-floor hallway and sitting room and near the first-floor keeping room—a multiuse room just off the kitchen featuring a fireplace for warmth.

The spirit who roamed the Richard Woodnutt House was never malicious. She was simply trying to seek out and get the attention of men around her age.

In April 1997, author and paranormal enthusiast Ed Okonowicz released a new book in his Spirits Between the Bays series titled *Presence in the Parlor*. Okonowicz wrote about the hauntings at the Richard Woodnutt House in this volume, describing Sarah and her search for the perfect man.

Shortly after the book was released, the owner of the inn said she received call after call asking about the resident spirit, and most made reservations.

Because of the popularity generated by Sarah's story, the owner decided to make the spirit a welcomed part of her hospitality business. Sarah was made a "partner" in the business and was mentioned in the brochure for the bed-and-breakfast.

Back in the late 1990s, Okonowicz returned to the inn for a book signing event where he also dimmed the lights and told ghost stories associated with the historic building.

I wanted to seize the opportunity to both meet the author and explore the haunted inn, so I attended the event. The interior of the bed-and-breakfast was beautiful. I can remember the feeling of calm creepiness while inside—calm because the place was quite cozy, but creepy because Sarah's presence was apparent.

I was able to explore all three floors and visit Sarah's stomping grounds, but because I didn't fit her criteria, she never made herself known to me—well, not until I left the building.

After a fun evening of hearing ghost stories and talking to Okonowicz about writing, everything paranormal and the spirit of Sarah herself, I said my goodbyes and left the building.

It was late when I left, and I was parked across the street from the inn. As I walked to my car, I could feel someone watching me. It was like her stare was burning a hole in the back of my head.

When I reached the other side of the street, opposite from the haunted bed-and-breakfast, I turned around to face the Richard Woodnutt House.

I gazed up at the windows on the upper floors, looking for a thirty-three-year-old woman perhaps peering back down at me. I didn't see anyone, but I know she was there.

Sadly, the Richard Woodnutt House is no longer a bed-and-breakfast. The building is now boarded up and abandoned—or is it?

SALEM CITY CAFÉ/GARWOOD HOUSE

Near the corner of Market Street and Route 49, just across the street from the Salem County Courthouse, is the historic Garwood House, most recently called the Salem City Café, but now unfortunately sitting empty after the café closed its doors permanently in September 2014.

The four-story Garwood House is the oldest public house in Salem, dating back to its established date in 1737.

The building has served as a private residence, a hotel, a stage office, a cigar manufacturer and finally the Garwood House, for which it is most well known in recent years.

After the Garwood House closed, the building sat empty for about seven years before Mike and Debra Foglietta purchased the historic structure in 2006 and opened the Salem City Café on New Year's Eve 2008 after completing extensive renovations and remodeling throughout the building.

The urbanesque café provided a city-like ambiance with a bar and lounge, dining room and banquet rooms. But while the café appeared quite contemporary inside, the rich history and spirits associated with that history remained in the historic building despite the remodeling and modern décor.

The Fogliettas and their staff began having strange experiences in the café when the building was being remodeled, but one of the first reported incidents came from a cook. The cook stayed at work late one evening to do some prep work for the next day.

The cook told his boss that, first of all, he was sure that he locked all of the doors after his fellow employees left for the evening.

He spent a couple hours in the kitchen on the first floor, chopping and prepping ingredients for the next day's menu. When he was finally finished and had cleaned up, he climbed the stairs to Debra Foglietta's office on the second floor where a bank of security television screens was located.

The cook said he happened to glance at one of the screens and saw someone walking around in the bar area on the floor just beneath him.

He knew everyone had left for the night except for himself, and he had locked every door to the outside. But he was looking at what seemed to be the figure of a person wandering around the bar on the first floor.

Foglietta said the cook told her the figure "walked in a circle, then just disappeared."

But the figure then appeared on the screen broadcasting from the security camera placed in the dining room. The same figure walked around the room and, once again, disappeared.

The cook never believed in ghosts, but after seeing an apparition with his own eyes on the restaurant's security camera feed, he was frightened and told Foglietta he was afraid to go back downstairs.

He eventually got himself together and left the building for the night, but the claims of paranormal activity go well beyond the cook's experience with the restaurant's security camera system.

Employees have reported seeing shadows in the basement, hearing footsteps on the upper floors and experiencing strange sounds and feelings in all parts of the building.

After the cook reported seeing the ghostly figure on the first floor, the owners decided to call in a team of paranormal investigators to see if they had inherited a few new friends when they purchased the landmark Salem City building.

Paranormal investigators Jersey Unique Minds Paranormal Society visited the restaurant for the first time in October 2010. During the investigation, the sound of disembodied footsteps was captured on one of the many audio recorders set up throughout the building. Near the end of the night, two investigators were on the fourth floor, which is mostly unfinished, when they started getting strange readings on one of their EMF meters.

There is no power on the fourth floor; however, there is a sprinkler system in the ceiling made of copper as per fire code regulations. While copper is said to give off its own EMFs (electromagnetic field), it was discovered after listening to the audio recorder that was on the fourth floor that the high readings were accompanied by a male voice. The investigators were unsure what the voice was saying, but the sound of a voice came through loud and clear.

In July 2011, the JUMPS team returned to the Salem City Café to look further into the possibility that the eatery was haunted. During this visit, an investigator said he heard whispering with his own ears, and an audio recorder captured an EVP of a woman saying "Hello" in the basement.

I had read about the history and all the hauntings at the Salem City Café before I officially became a paranormal investigator, so of course, once I got my ghostly wings, I was hoping to have the opportunity to visit the restaurant with my ghost hunting apparatus and fellow investigators.

That opportunity finally came in September 2013, and the café didn't disappoint. Looking past the sophisticated veneer, the past is still ever present in the appearance of the café. It's not a surprise that some of the people who frequented the building over the past three hundred years—whether as a hotel guest, stagecoach driver or cigar maker—resigned to remain within its walls.

One outcome of the three investigations that were conducted at the Salem City Café is that some of the spirits who linger there could be of the residual type.

A residual haunting is one that is actually caused by the energy that is left behind by a person who passes away. Some of our energy remains embedded in a place we loved or where we died, like an impression in time. Residual activity is a paranormal experience that plays over and over like a recording and is not considered an intelligent haunt.

An example of a residual haunting would be activity that happens at the same time of day, week or year. If a homeowner sees a woman walk through the living room and disappear into a wall at 4:35 p.m. every day, that woman most likely did just that every day while she was alive. Her energy was burned into the atmosphere of the home and continued doing what it was used to doing after her death.

Unfortunately, the Salem City Café is still closed, but from what was discovered during the paranormal investigations conducted there, it's most likely not empty.

Finn's Point National Cemetery

Spirits Old and New

Pennsville

In 1859, Fort Delaware was built on Pea Patch Island, which lies in the middle of the Delaware River just off the coast of Pennsville in Salem County.

Fort Delaware is part of a three-fort system that also includes Fort Mott in Pennsville and Fort DuPont in Delaware City, Delaware. The three forts were built directly in line with one another, forming a triple-fort formation to protect the ports of Wilmington, Delaware, and Philadelphia, Pennsylvania, from any river attacks during the Civil War.

Even though the three forts never saw any combat action, Fort Delaware was used as a prison for Confederate prisoners of war who were captured up and down the East Coast. The conditions at Fort Delaware were deplorable, and many inmates came down with diseases such as smallpox, measles, dysentery, scurvy and other contagious illnesses.

Those illnesses led to the deaths of thousands of POWs, and others died of malnutrition and neglect due to the immense overpopulation at the fort.

In 1863, the property at Finn's Point became a cemetery for the Fort Delaware prisoners who died while in captivity there. By July 1863, more than 2,400 prisoners had died and were buried in a mass grave at Finn's Point. The cemetery also became the final resting place for 135 Union guards who died while working at Fort Delaware.

The Union monument at Finn's Point National Cemetery in honor of 135 Union guards who died while on duty at Fort Delaware, Pennsville. *Author photo*.

An informational sign near the caretaker's house at Finn's Point National Cemetery in Pennsville. *Author photo*.

There are two massive monuments at the cemetery today: one for the Union guards and one for the Confederate soldiers. And while the Confederate monument doesn't sit directly over the mass grave, it's not hard to find where the thousands of soldiers are laid to rest. There is a large pit in the center of the grassy northwestern section of the cemetery. The dip in the earth marks the resting place of those 2,400 Confederate soldiers.

The graveyard was officially made a National Cemetery in October 1875, and today, it is the resting place for more than three thousand souls.

With more than 2,400 of them piled in a mass grave—many having died painful deaths from disease and suffering—the energy at Finn's Point National Cemetery is impossible to ignore.

As can be expected, there are many ghost stories associated with Finn's Point, nearby Fort Mott and Fort Delaware over on Pea Patch Island—the place where so many of the interred lost their lives.

Most of the prisoners fell ill and died from disease. But at least one young soldier lost his life while trying to flee from his imprisonment.

This prisoner allegedly attempted to make his escape by faking his death. He ended up being buried alive on Pea Patch Island instead of being put

Looking through the iron gate at Finn's Point National Cemetery in Pennsville. *Author photo.*

A line of headstones at Finn's Point National Cemetery in Pennsville. *Author photo.*

onto a boat that was headed to the mainland where he planned to make a run for it. The man died on the island and has been seen wandering around the area.

Many war prisoners who spent their last days at Fort Delaware came from Southern states such as North and South Carolina. They were captured and brought to New Jersey, where they were imprisoned and then died. Now, their souls are lost and wandering, wondering how to get back home.

While those spirits could explain many of the ghostly sightings that have been reported throughout the years and most of the creepy feelings visitors experience at Finn's Point, the cemetery's normal atmosphere is very quiet, comfortable and serene.

Situated near the Delaware River behind Fort Mott State Park and surrounded by the Killcohook National Wildlife Refuge, Finn's Point National Cemetery is a peaceful and beautiful place to visit.

Located at the end of what is known as Cemetery Road, just about a mile off Fort Mott Road—which is a dead end—Finn's Point Cemetery is a tough spot to just happen upon if you are from out of town.

However, on May 9, 1997, serial killer Andrew Cunanan somehow found his way to the cemetery caretaker's house and disrupted the serenity of the sacred land.

Cunanan, a California native, drove down Cemetery Road in a car that belonged to his third murder victim, Lee Miglin of Chicago, and came upon Finn's Point National Cemetery.

There, he approached the caretaker's house and knocked on the door. William Reese, the cemetery's longtime caretaker, answered the door to the stranger's knock and let Cunanan inside. While it's not known exactly what occurred in the next few moments, what is known is that Cunanan forced Reese down into the building's basement, where he shot the man execution style in the back of the head.

After growing up in Pennsville and visiting the cemetery and surrounding area quite often, I knew Mr. Reese and always thought of him affectionately and with much respect. So, when my telephone rang at 9:30 p.m. on the evening of May 9 and it was my editor telling me to go to Finn's Point to cover a murder, it was a bit unnerving. Not to mention, I had only just kicked off my journalism career a couple months prior to that fateful evening.

I was stationed on Fort Mott Road, about a mile from where the murder had taken place, amid television news crew vans, police cars and curious townsfolk.

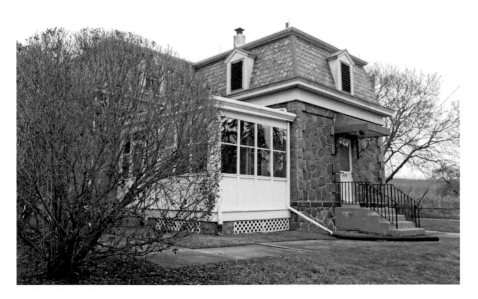

The caretaker's house at Finn's Point National Cemetery in Pennsville. *Author photo.*

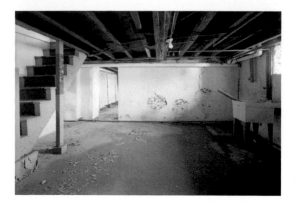

The basement of the caretaker's house at Finn's Point National Cemetery in Pennsville. *Historic American Landscapes Survey, U.S. Department of Veterans Affairs.*

Shortly after 2:00 a.m., a flatbed truck brought Miglin's car out of the cemetery. After Cunanan killed Mr. Reese, he stole Reese's red pickup truck and continued traveling south. He killed Gianni Versace on July 15 and finally took his own life on a houseboat in Miami on July 24.

I covered Cunanan's every move until the night he chose to take his own life. None of his victims, including Mr. Reese, had a choice, so why did he?

The entire incident was very emotional for me and still is to this day.

Following the story and continuously writing about the murder of someone I knew, which happened in one of my favorite places, was not easy. But, for all the hard work, I did win a third-place New Jersey Press Association award for covering the murder and aftermath of Cunanan's visit.

I stayed away from Finn's Point National Cemetery for several years after the murder. One of my first visits back was with my paranormal investigation team. We were hosting a Halloween historic ghost tour, and the cemetery was one of the stops. The investigators were to conduct EVP and K-2 sessions in different areas of the cemetery to show the tourists how we do what we do. We also hoped to pick up some evidence while we were there.

The evening was going well until I was asked to take some equipment over to the house and conduct an EVP session on the cement steps leading to the basement where Mr. Reese was murdered.

Not wanting to appear weak or scared, I gathered my equipment and walked with two other investigators across the field to the ominous building. When I arrived at the descending steps—trying not to show how uncomfortable I really was—I walked down the short staircase.

It was twilight, and there were no lights on inside the basement, so when I looked through the small glass window in the basement's exterior door, I was looking into complete darkness.

I didn't like it.

I didn't like the feeling I got standing near the door, and I didn't like staring into the pitch-black basement, knowing Mr. Reese had lost his life there.

Trying not to look shaken, I got back onto the cement steps and took my place on the second one from basement level. I was still uncomfortable, but it was a bit easier not being face to face with the glass pane that looked into the basement.

I began the EVP session by explaining that I was involved in covering Mr. Reese's murder and that it was very emotional for me to be standing just outside the room where he was killed.

Suddenly, as I spoke, my K-2 meter began registering a change in the electromagnetic field around me.

"Mr. Reese, is that you?" I asked, on the verge of tears. But the meter went back to normal.

"If Mr. William Reese is here, please make my [meter] lights light up," I pleaded, but to no avail. "OK, if you're not Mr. Reese, can you make my lights light up?"

In just a few seconds, the K-2 came to life once again.

Was I disappointed that it wasn't Mr. Reese? Somewhat, because I would love to tell him how sorry I am for what happened to him. But, on the other hand, I hope he is somewhere peaceful—not stuck in the building where he was so brutally murdered.

In addition to the K-2 meter and audio recorders, we brought along a piece of investigative equipment called the Ovilus III, or "Spirit Box."

The Ovilus III is an electronic speech-synthesis device that utters words, depending on environmental readings, including electromagnetic waves.

Basically, this gadget claims to be able to pick up what a spirit is trying to say and relay that word through the use of a 2,500-word dictionary that has been programmed into the machine. The Ovilus III can literally speak for the spirits if it is manipulated correctly.

So, using the device along with our other equipment, I asked who was making the K-2 readings go off the charts.

The Ovilus produced the name Tom.

This is significant in that while there are names programmed into the gadget, there are more common words that are more readily produced, like "train" or "happy," than someone's name.

I took the cue and asked if there was a spirit nearby named Tom.

The K-2 meter lit up all the way into the red, which includes every light on the device. Having a reading go into the red is very rare and indicates a very strong energy.

Left: The caretaker's house at Finn's Point National Cemetery in Pennsville. *Historic American Landscapes Survey, U.S. Department of Veterans Affairs.*

Below: Finn's Point National Cemetery in Pennsville. *Author photo.*

Not even a minute later, the Ovilus spat out the name Veronica.

Perhaps Veronica was also present or Tom was looking for a woman named Veronica.

"Were you married to Veronica?" I asked in amazement.

Once again, the lights on the K-2 meter glowed.

The interaction continued until we were forced to leave the basement steps and board the tour bus to travel to another historically haunted location.

An audio recorder was busy doing its job during the entire session, but after listening, only a few questionable EVPs were recorded. One sounded

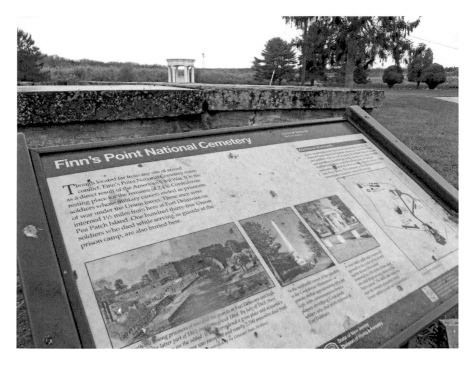

An informational sign at the entrance to Finn's Point National Cemetery in Pennsville. *Author photo*.

like a strange breath near the microphone and the other could have possibly been a low voice, but the words were inaudible.

The fact that the K-2 meter reacted in such a way in an area where there were no electrical devices to set it off accidentally was excellent evidence that a spirit could have, in fact, been communicating with us. Was that spirit Tom who had been married to Veronica? That's something we may never know for sure. But whether it was or was not, we were definitely interacting with something on those eerie steps leading to the unsettling basement where the cemetery's beloved caretaker so unfairly lost his life.

THE LEGEND OF BERRY'S CHAPEL

QUINTON

Every small town has a legend, whether the tale is simply whispered between friends at a slumber party or makes national news.

Quinton Township in Salem County is home to one of New Jersey's most infamous ghost stories—one that is actually based in truth.

Ask anyone in Salem County and the surrounding area about Berry's Chapel, and the response will be something like this: "I went back there years ago. It was creepy!" Or, "I heard if you go back there, you'll see a guy hanging in a tree."

And if they haven't braved the forest of Quinton and explored the legendary land, they've most likely heard stories about the history of Berry's Chapel.

The true story of Berry's Chapel is rooted in a small African American community that developed deep in the Quinton woods in the 1800s.

Pastor Charles H. Berry established a Methodist congregation and constructed a small, log cabin–style church building on his property, where the community could come together to worship. A small cemetery was established adjacent to the parish. The church became known as Berry's Chapel.

Many legends surround the history of Berry's Chapel—some of them positive, some of them positively terrifying.

Left: The headstone of Pastor Charles H. Berry and his wife, Agnes, lying knocked over at the sight of Berry's Chapel in Quinton. *Author photo.*

Right: The headstone of H. Lloyd lying on the ground at Berry's Chapel in Quinton. *Author photo.*

It has been said that Berry's Chapel was part of the Underground Railroad and was an essential stop for slaves fleeing from the South to the freedom of the North.

However, there are also tales of the Ku Klux Klan terrorizing Pastor Berry and his congregation. One story that has been passed down through the generations is that KKK members disrupted church services and threatened the churchgoers. Another tale claims that Pastor Berry was hanged by the KKK and the church was set on fire sometime in the early 1900s, but no one was harmed. Some say it caught fire later and burned to the ground, taking the entire congregation and Pastor Berry along with it.

Others say the church was abandoned in the 1920s and fell into ruin after a new, more modern church was built on Bridgeton Pike.

Most of these stories have not been validated, but that fact has never deterred locals from braving the dirt roads and darkness in the hopes of catching a glimpse of the chapel's haunted past.

In the 1950s and '60s, teenagers discovered the old, dilapidated church in the woods and started using Berry's Chapel as a party spot. The rebellious youth would descend on the property, vandalize the church and desecrate the graves that lie forgotten in the woods.

The small cemetery became a target for unruly visitors. Bodies were dug up and the bones of the deceased were strewn about the area. Graves were left empty—ghoulish holes in the once sacred ground.

Finally, officials stepped in, exhumed the remaining bodies and moved them to the cemetery that lies under the Salem Oak Tree on Route 49 in Salem.

However, some of the headstones, including the one belonging to Pastor Berry and his wife, remain in the woods at Berry's Chapel.

As is expected, these grisly tales brought with them ghost stories that grew and grew and became more and more frightening with every telling.

Some stories that have been handed down through the generations include visions of the original church burning in the night, a pair of glowing eyes that appear in the woods and the figure of a man hanging from a noose in what is referred to as the Hanging Tree.

Since some stories surrounding the demise of the church include fire, one of the most well-known ghost stories about Berry's Chapel involves bright, frightening flames. It has been said that, on certain dark evenings, those who wander into the Quinton woods can see the church, still standing but engulfed in flames. Some say parishioners can be heard singing and praising within the burning walls of Berry's Chapel. Others say the sounds of metal scraping and people screaming fill the silent forest.

The Hanging Tree, a huge tree that stands near the plot of land where the church once stood, supposedly has no bark or leaves but is very much alive. It's been said that there is a bulge on one of the larger branches that looks like the spot where the tree grew around a rope that may have been tied around it—a hangman's noose perhaps?

Several visitors have also reportedly seen glowing eyes staring at them from among the trees, heard conversations between disembodied voices, witnessed a mysterious white wolf prowling the woods and have even seen Pastor Berry himself swinging by the neck from a tree.

I took my first trip to Berry's Chapel just a few years ago. There's nothing left of the church, but it's easy to figure out where it stood because there are no trees or shrubs growing in the church's footprint.

Of course, I brought along some equipment to see if I could pick up any signs that there are still spirits lingering in the woods near the place where Berry's Chapel once stood. Three fellow investigators and I placed audio and video recorders, in addition to K-2 and Mel meters, throughout the area. As the sun dropped lower in the summer sky, I kept my eyes peeled for flames, glowing eyes or a swinging body but saw nothing out of the ordinary.

In fact, we didn't pick up anything on audio or video and had no personal experiences while wandering around in the supposedly haunted woods.

Many headstones have been knocked over at Berry's Chapel in Quinton. *Author photos.*

After our disappointingly quiet trip to Berry's Chapel, I reached out to several people who had told me they had strange experiences at Berry's Chapel. I told them we didn't see anything paranormal or collect any evidence, and oddly, everyone clammed up.

While legends and ghost stories are exciting and keep the history and memories of small towns alive for hundreds of years, there is a significant difference between a legend and a haunting—between a ghost story and a paranormal report.

Does the fact that we found no evidence on our trip prove that Berry's Chapel is simply a legend? Are the tales just ghost stories dreamed up by the imaginations of teens who may have indulged in too many spirits themselves?

Or were the spirits quiet during our visit?

Is Berry's Chapel merely a legend? Or could the spirits of those who were tormented, burned or hanged and whose graves were desecrated and bodies exhumed for pure entertainment still be lost in the woods of Quinton Township?

INSANITY IN MANNINGTON

SALEM COUNTY INSANE ASYLUM, MANNINGTON

In 1870, Salem County constructed a three-story, county-run insane asylum, or almshouse, on what is now Route 45 in Mannington Township, to address a lack of state action and overcrowding in state-run facilities.

Known as the County Farm, the almshouse and asylum were located adjacent to each other and housed the county's insane until 1925, when the residents were then moved to the state facility, making room for the area's poor residents to move in.

In more recent years, the building was used by groups and clubs before being abandoned and boarded up, which is how it has remained for nearly ten years.

Today, the structure is failing. The floor has collapsed in several spots, and access is no longer allowed.

It's listed as one of the ten most endangered historic places in New Jersey by Preservation New Jersey, but its brick exterior is still standing strong.

While the building is boarded up and abandoned, it could possibly still be inhabited by patients from the past.

In November 2012, I accompanied Jersey Unique Minds Paranormal Society to the property after the group was granted permission to enter and explore the insane asylum. The Italianate cube-style structure had been boarded up for about seven years when we removed the wood that served as a cover for the main entrance and practically crawled inside.

Salem County Insane Asylum in Mannington. *Author photo.*

Upon entry, the scariest thing about the 150-year-old building was the piles of animal feces and dead insects we had to avoid.

But beyond the filth, peeling paint and stained carpets, I could see that the building was once quite residential-like. Since it was boarded up, it has become home to some wild animals that, luckily for us, must have been out hunting while we explored the once thriving institution.

We began to move through the building, setting up video cameras and placing audio recorders sporadically throughout the rooms. Luckily, we turned the devices on as we were setting them up—we didn't know it at the time, but we were not alone.

As soon as we entered the decaying asylum, a fellow investigator turned on her personal digital voice recorder and carried it with her during setup.

We had just entered the building, but listening to the recording after the completion of the investigation, we discovered the recorder picked up an EVP almost immediately.

The recording is of a male voice saying what sounds like "Go down." If there was a spirit present suggesting that we descend into the basement, it was preparing us for what would turn out to be a very interesting evening.

Unaware that we were being asked to go into the basement, I accompanied two other investigators up to the third floor.

While standing in the middle of the third-floor landing, equipped with my K-2 meter, digital voice recorder and camera, I neither felt nor heard anything out of the ordinary. The lights on my K-2 meter stayed dark, and my voice recorder didn't pick up anything except for my conversation with the other investigators, which included my statement, "All this feels like is standing in the dark in a creepy old building."

Little did I know, the night wouldn't remain so calm.

There was no strange activity on the second and third floors, but finally, late in the evening, I decided to investigate the basement where a few investigators had experienced some strange activity earlier in the evening.

Equipped with a night-vision video camera, three audio recorders, two K-2 meters, a Mel meter and a digital thermometer, I descended into the dark—and, yes, very creepy—basement with a group of investigators.

Those who had previously visited the basement experienced uneasy feelings, heard movement in the darkness and witnessed the batteries in various pieces of equipment drain quickly for no apparent reason. My digital camera, which was fully charged, shut off entirely as soon as I arrived in the basement. Later, after I was back up on the first floor, the camera turned on and regained full battery charge.

Strange.

We set up the cameras and placed the meters on an old metal barrel in the center of the main basement room. There were three smaller rooms on one side of the basement that we learned were once used as solitary confinement for unruly patients.

Once we got set up and settled into the darkness, we attempted to make contact with anyone who might be in the basement. We began asking questions, leaving plenty of time in between our inquiries for any spirits who were in the basement with us to respond.

It seemed to take quite a while, but eventually, we started getting responses to our questions. The K-2 meters began reacting to certain queries, so we asked whomever was present to use the two K-2 meters to communicate with us. We asked the entity to light up the meter on the left for a "yes" answer and the one on the right for a "no."

Everything was quiet until we explained that all a spirit needed to do was to get close to the K-2 and Mel meters to make the lights light up. Just after it was explained, the lights on every meter flashed for about five seconds.

To ensure the reaction was caused by a ghostly presence, we asked that if a spirit had indeed just made the meters light up, to please do it again on the count of three.

One. Two. Three. All the meters, once again, came to life.

We repeated this test a couple more times, and each time, the meters lit up on demand.

At one point, when a question about whether the spirit had lived in the building was asked, the temperature in the basement suddenly dropped from 42 to 35 degrees Fahrenheit.

That was the moment when one investigator felt her right hand starting to get abnormally hot. The EMF level surrounding the investigator rose from 0.4 to 0.9 as the sensation became stronger and hotter.

We asked if there was a spirit touching the investigator, and the K-2 meter on the left flashed to life, indicating a positive response. After that reaction, the investigator reported that the sensation began to fade and finally disappeared.

From that point, another investigator said she felt like someone was standing directly behind her. Then she felt an invisible arm wrap around her quickly before the feeling dissipated.

Not too long after the activity began to increase, it was apparently my turn to experience whatever was with us in the basement. I was standing perfectly still and there was no breeze, but my long hair was suddenly brushed aside by an unseen force.

The interaction continued for nearly a half hour until we asked if the spirit was happy that we were there visiting.

There was no response.

"Do you want us to leave?" I asked.

The K-2 and Mel meters immediately lit up to full capacity and remained glowing with hardly any fluctuation for several seconds.

I've always said that if I was ever investigating a location and was told to "Get out" or felt that whatever was present didn't want me there, I would leave.

This reaction made me feel like the spirit was done with the visit and wanted to be left alone. Therefore, we gathered up our equipment and left the basement.

While the personal experiences in the basement were amazing, we still had to rely on video or audio evidence to determine if it was haunted or not.

So, the next day, while listening to audio recordings that were captured in the basement, I discovered some unsettling evidence.

While we were conducting the EVP session, right when we were beginning to get responses out of the K-2 and Mel meters, my recorder came to life with groans, sounds of motion and what sounded like aggravated breathing very close to the microphone.

Legend has it that patients were chained up in the individual rooms that make up the basement. This could be the reason why most of the evening's haunting experiences occurred in that creepy underground dungeon.

Since that evening when we were given permission to enter the historic building, the Salem County Insane Asylum has been condemned, and visitors are no longer allowed to go inside due to the instability of the floors.

Because the asylum is the only known surviving example of a first-generation county insane asylum, it is very important that the building be saved. However, the longer it sits abandoned, the greater the chance of it deteriorating beyond repair.

For history's sake, hopefully the county can find the means to restore and rehabilitate this piece of history.

WOODSTOWN TAVERN AND HOTEL

A TAVERN FULL OF SPIRITS

WOODSTOWN

Most haunted locations have tragic stories associated with them, normally concluding with the death of one or more people within the location's walls.

But one of the most famous tales linked to the Woodstown Tavern and Hotel involves the failed assassination attempt of local politician John Holmes.

Woodstown was established in July 1882 after a referendum split portions of Pilesgrove Township into separate communities: Woodstown Borough and Pittsgrove Township.

Pilesgrove Township, a large farming community in Salem County, was settled in the early 1700s primarily by the religious Society of Friends—a Quaker organization.

The earliest mention of the township was in a deed dated April 1701, and Pilesgrove was one of the original 104 townships first incorporated in New Jersey.

In 1818, before Pilesgrove was sectioned off to make several other municipalities, an acre of land in the center of what is now the borough of Woodstown was purchased by a man named Daniel Sheppherd.

The land sat dormant for nearly twenty years until Jacob B. Keely acquired the property in 1836 and built a majestic, three-story building featuring a stately tavern on the first floor and several guest rooms on the upper floors.

When the tavern and hotel first opened, it was known as the Washington House—a popular stagecoach stop for travelers headed for destinations such as Philadelphia.

Haddonfield's Samuel French purchased the Woodstown Tavern and Hotel in 1880 and operated the establishment until his death in 1909. French was the most prominent owner of the property in its early heyday and actually ended up dying inside the building.

John Holmes, a mayoral candidate, had stopped by the tavern to visit with French in March 1886. The men were relaxing in the front sitting room when a bullet suddenly broke through the window and allegedly struck Holmes's leg, leaving only a flesh wound.

While Holmes made it out of the tavern alive that day, French and many others died within the establishment's walls over the next several years.

During the nearly one hundred years after French's death, the hotel's ownership changed hands countless times, but the bar remained a favorite watering hole for locals and visitors alike.

It's difficult to even imagine how many people have passed through the doors of the stately building and even harder to figure out how many still remain.

There have been many claims of paranormal activity in the bar, basement and guest rooms on the upper floors during the business's nearly two-hundred-year history.

Sounds of people talking and walking around when no one is present, strange shadows lurking in corners and objects moving on their own or disappearing completely are just some of the incidents that have been reported by employees and guests of the Woodstown Tavern and Hotel.

In 2014, I accompanied a few investigators to the historic spot, where we set up video cameras, audio recorders, K-2 meters and several other pieces of equipment to help us capture evidence that would solidify some of the claims that had been made over the years.

Apparently, the resident ghosts were ready to show themselves that night, because the first strange occurrence happened before the investigation even officially started.

We set up cameras in the bar, attic, basement and dining room, which was being remodeled during our visit. After all the cameras were placed, I was in the kitchen—which we were using as base for the evening—checking the video feed on our video monitor.

Each camera was attached to a tripod and standing in a corner or doorway in order to capture the entire area it was aimed at—each camera, that is, except for the one recording the dining room.

Because there was a metal ladder in the dining area that was being used during the renovations, we decided to use it as a makeshift tripod. Electrical tape was used to tightly secure the camera to one of the higher steps on the ladder to get a more elevated view. However, despite our efforts to anchor the piece of equipment to the rung, the camera ended up on the floor in front of the ladder.

The mishap was chalked up to a faulty tape job, and the camera was once again attached to the step, this time using at least twice as much tape.

I was in the kitchen—which is located adjacent to the dining room—with a group of investigators watching the video feed coming in from the cameras that were placed throughout the building.

As we watched, a fellow investigator noticed something strange moving in front of the dining room camera—the one propped up on the metal ladder. Wondering what it could be, I decided to leave the kitchen and check it out.

Because of the renovations, the section of the dining room where the ladder holding the camera stood was concealed by plastic panels hanging from the tile ceiling.

I stepped out of the kitchen but hadn't quite made it inside the plastic covering when I heard what sounded like the entire ladder crashing to the floor.

I hurried through the plastic draping and discovered that the ladder was still standing in its place, but the camera had once again fallen to the floor. This time, it landed several feet away from the ladder, outside the hanging plastic. There was no explanation for why the camera fell from the ladder again. And none of us could fathom how it flew as far as it did and was not destroyed.

After the investigation, while reviewing video footage, it was discovered that the camera was indeed functioning when it toppled to the floor. The point-of-view recording of the first fall shows the camera sitting completely still and then falling forward, as if someone pushed the top of the camera straight down, causing it to plunge to the floor. The film also shows that the camera hit the ground hard and rolled around a bit before coming to rest with the lens aimed at the ceiling.

Video footage of the second fall shows a similar scenario, even after the camera was reinforced with more tape and situated more securely on the ladder. The camera falls forward—slowly at first, before going into a complete freefall—and turns end over end through the air, before landing on the floor on its side. Once it comes to a halt, several feet away from the ladder, there seems to be some interference in the feed, causing the picture to jump several times.

The video camera wasn't the only piece of equipment that was manipulated by some unseen force during the investigation.

While we were setting up equipment, I placed a laser light grid on a wooden shelf in the bar area and, again, taped it securely in place. A laser light grid is a small, flashlight-style tool that projects hundreds of tiny laser light points onto a solid surface such as a wall. If something moves through the laser dots, the lights black out, making it easier to see the movement.

I had just put fresh batteries in the light and aimed the grid toward the bathroom hallway, so the lasers encompassed the entire area at the end of the bar.

Once I was satisfied with its placement and made sure it was not going to move, I accompanied a fellow investigator to the basement.

After just a few minutes, an investigator who was still upstairs in the bar area called down to me on a walkie-talkie. He said he had seen the laser grid set up where I placed it, but the next time he looked over, he noticed it was dark in that area of the bar.

He approached the laser grid, thinking the batteries had died, but noticed the entire object had moved.

The light had been aimed at the back of the spacious barroom. When the investigator went to check out why the lasers had disappeared, he saw that the flashlight had spun around nearly 180 degrees and was now facing the side wall. And it was dark because the light appeared to be turned off.

In addition to the light mysteriously spinning around to face the wall and turning off, the bulb end of the flashlight was loose and fell off when the investigator attempted to turn the light back to where I had originally placed it.

The illuminated end of the light can be turned to change the light pattern but does not come off unless someone intentionally unscrews the end.

Because the light was turned off and disassembled, he took the light back to base to put it back together and hopefully repair it to use later in the investigation.

When I returned from spending about forty-five minutes investigating the basement, I put new batteries in the laser light—even though I knew I had just put new batteries in the device—and took it back out to the bar. I placed it on the same shelf and taped it back in place.

The light remained lit and in place for the rest of the night.

However, after reviewing the copious amounts of audio and video footage obtained during the investigation, we discovered the building was anything but quiet.

Several EVPs were captured, and at least two of those could be considered a "Class A EVP"—one that is clear and easily understood.

With four floors to explore, the group of investigators broke into pairs and were rarely in the same location or even within earshot of each other.

A pair of investigators were in the basement using K-2 meters to measure the EMF levels and a digital thermometer to check for cold spots while conducting an EVP session. There were only three men in the building during the investigation, and one of the investigators in the basement was male. The other two men were in the attic, three floors away from the basement.

As the pair moved through the basement, they noticed that the temperature suddenly dropped, and the EMF levels began to rise.

While they were discussing the changes in the atmosphere, the male investigator heard a man call out his name.

There was no way the voice he heard belonged to a living, breathing human, since the only other men in the building were well out of reach.

The voice was captured on the audio recorder, providing a clear, Class A EVP. The astonishing part of this EVP is its clarity and the fact that the investigator heard it live during the investigation. His partner didn't hear it

The Woodstown Tavern and Hotel was established in 1882 and has seen its share of tragedy during its 130-plus years in business. *Author photo.*

at the time, but thanks to the audio recording, we could tell that the voice is very clearly male, and it is coming from somewhere in the basement.

The other Class A EVP was also captured in the basement, but this time, there was no one down there—at least no one of flesh and blood. All of the investigators were regrouping at base in the kitchen on the first floor when the audio recorder that was left running in the basement captured a voice that seemed to whisper the name Ethel.

Up until the early 1900s, segregation was a way of life for the thirsty patrons who frequented the tavern. Black customers were welcome but drank at a bar located in the basement. The staircase that they once used to descend into the lowest level of the building is still standing today. However, the entrance has been blocked by the floor above, giving the steps the appearance of going nowhere.

The voice, seemingly talking to Ethel, was captured near what we came to call the "stairs to nowhere."

Perhaps Ethel was a barmaid and a patron who has yet to leave the bar was calling to her for a refill. Or maybe she was a customer herself and someone was searching for her. Whoever she was, someone said her name in the basement that night, and it wasn't one of the investigators.

In addition to these two EVPs captured in the basement, the recorder in the bar also picked up two voices that aren't as clear but are definitely out of place. The first was a female voice and, once again, was heard in real time by two investigators.

Three investigators—two females and one male—were spread out around the bar when the male heard a female voice. He assumed it was the voice of one of the women who was in the room with him, but immediately after he dismissed the voice, one of the females asked if someone had said something. No one had.

The investigators questioned if they had actually heard the voice, but after reviewing the audio footage, their questions were answered.

The words are inaudible, but the voice is definitely there.

Another EVP was captured as the investigators were leaving the bar area. The recorder, which was left on the bar, picked up another muffled voice as the investigators were descending the steps into the basement.

Even though neither of these is understandable, the voices are disembodied, meaning that a ghostly presence was trying to communicate something to the investigators.

After reviewing hours and hours of video footage from the many cameras placed throughout the building, it was discovered that the ghostly inhabitants

were not only trying to get our attention verbally but also trying to manifest themselves so they could be seen.

As in every investigation, the video cameras picked up hundreds of orbs. Orbs are normally the bane of a paranormal investigator's existence because these reflections are immediately considered ghosts by most who see them in photographs or on video.

Most orbs are caused by light reflecting off of dust, insects or moisture in the air. They can also be caused by a camera's flash reflecting off of glass or a mirror and by lens distortions. Orbs are even more common today with the widespread use of compact and ultra-compact digital cameras.

So, while most orbs are not paranormal in any way, once in a great while, a real energy orb is captured in a picture or video.

Genuine spirit orbs give off their own light and are usually mostly solid, making them brighter than the dust or insect orbs around them. These energy orbs sometimes leave a contrail, similar to a meteor, that appears as a streak of light in a photograph or is visible in video.

Authentic orbs are believed to be the culmination of leftover energy from a living being and usually travel in random patterns and speeds, not in straight lines.

During the investigation, we saw a plethora of orbs caused by dust, especially in the basement and the attic.

But while watching the footage, we noticed a few light anomalies that appeared to be more than just tiny dirt particles floating in the air.

A video camera set up in the attic picked up a strange, slow-moving orb while three investigators and the owner of the tavern were exploring the uppermost level of the building.

The owner was sitting at the top of the steps leading to the floor below, while the investigators were standing around, scattered in different areas of the attic. The first strange orb came from the area where the man was sitting at the top of the stairs, moved slowly upward and to his left and then turned slightly right before disappearing.

The second questionable orb appeared near the roof and traveled slowly downward beside one of the female investigators until it disappeared off the video screen.

Later in the evening, two investigators were investigating the attic when the video camera captured a small but bright orb coming from in front of one of the investigators. It changed direction and disappeared into the back of her leg.

Downstairs in the bar area, a flashing ball of light was captured traveling from the bathroom hallway, along the bar and finally past the camera's

lens. This orb, which resembled someone coming out of the bathroom and returning to their seat at the bar, was flashing its own light and definitely following a distinct route around the bar. The orb had a visible tail and gave off its own light.

The few hours I spent at the Woodstown Tavern and Hotel were quite eventful and yielded several pieces of strong evidence, not to mention a handful of unexplained personal experiences.

With nearly two hundred years of history, countless visitors to both the bar and hotel and all the claims of paranormal activity over the years, it's not a surprise that the historic building has a few ghostly occupants.

CREEPY TALES OF CUMBERLAND COUNTY

11

THE MYSTERIOUS HISTORY OF BRIDGETON'S MASONIC LODGE

BRIDGETON

The Masonic Fraternity, or Freemasons, is one of the oldest social organizations still thriving actively throughout the country. One of the first mentions of the Masons can be found in the 1390 printing of *Regius Poem*, which was a copy of an earlier version of the prose.

While no one knows the exact date the organization formed, we do know that by 1717, there were four lodges in London that made up the Grand Lodge of England. Since that formation, records are much more complete, and the fraternity's history can be followed as the organization spread throughout Europe and across the Atlantic to the American colonies.

Many founding fathers, including George Washington, Benjamin Franklin, Paul Revere and John Hancock, were all Masons.

Organization members focus on personal study, self-improvement and social betterment through individual involvement and philanthropy. Masons also spread the ideals of the Enlightenment—the dignity of man and the liberty of the individual, the right of all persons to worship as they choose, the formation of democratic governments and the importance of public education—having supported the first public schools in Europe and America.

These traditions are still alive today, and the Masonic Fraternity provides millions of dollars in funding to countless causes, including the operations of children's hospitals, treating eye disorders, funding medical research and providing care to Masons and their families at Masonic homes.

While the Freemasons are well known for their community service and philanthropy, the Masons have been shrouded in mystery for hundreds of years.

However, hauntings aren't prejudiced about where they linger.

The paranormal research field has literally opened doors that otherwise remain closed to the general public—doors to historic locations, private residences, backstage at legendary theaters and businesses.

But I never imagined the members of a Masonic lodge would open their doors to a paranormal investigation.

Master Neulin Williams of Brearley Lodge No. 2 in Bridgeton welcomed Jersey Unique Minds Paranormal Society into the lodge in July 2015 after several unexplainable incidents occurred inside the more than two-hundred-year-old lodge building.

Brearley Masonic Lodge was built in three sections. The original structure—now the front of the building—was built in 1797. The first floor was the first public school in Bridgeton. The middle section was built in 1873, and the back section was built in 1968.

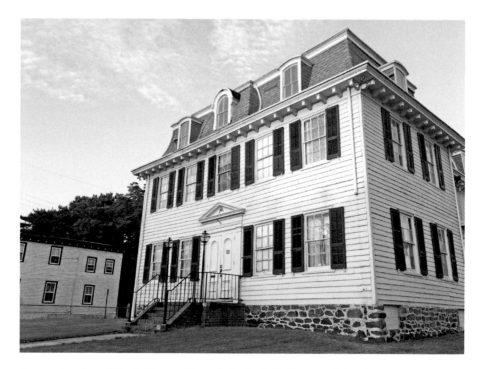

An exterior shot of the Bridgeton Masonic Lodge in Bridgeton. *Author photo.*

Members have reported hearing footsteps on the second floor while everyone is on the first floor or hearing movement in the dining room while everyone is sitting in the front room.

Williams himself had a startling experience at the lodge that prompted him to finally reach out to paranormal investigators.

While remodeling the first-floor bathroom in the section of the building that dates back to 1797, Williams heard someone approaching him.

"I was kneeling, and I heard footsteps coming up behind me," he said. "Then, I saw legs from the knees down wearing britches and high socks and old-style shoes."

The legs disappeared, but Williams swears he saw the apparition, and his story hasn't faltered a bit since the occurrence.

For several years, members have reported activity on both main floors, plus the basement and the attic. So, when we set out to explore the building, we were sure to cover the entire place with video and audio recorders.

The basement that lies under the front section of the lodge also dates back to 1797 and very much looks the part—dark, damp stone walls, dirt floors and stacks of old Masonic books, including rituals and degrees.

In an attempt to stir up some activity, two other investigators and I opened one of the dusty books and began to read. We knew we were most likely forbidden to do so, but we only read a small part of the beginning of one of the sacred manuals.

The three of us were conducting an EVP session while examining the book. As we read, the atmosphere seemed to thicken, and I began feeling a bit tense. I thought maybe it was just because we were doing something we probably shouldn't have been doing, but in the back of my mind, I wondered if the uneasy feelings were due to an unhappy spiritual presence.

We had been in the basement for about twenty minutes when suddenly my curiosity of whether we were alone or not was confirmed.

As a fellow investigator was reading a passage from one of the books, I experienced what felt like someone poking me in the lower back with their finger. There was a lot of pressure behind that phantom poke, so when I reacted to the surprise, one of the other two investigators questioned what had happened.

When I told him I had been poked in the lower back, he immediately turned around and held the Mel meter—which had been reading a steady 0.1 or 0.2 all evening—behind me where someone would be standing in order to poke me. The Mel meter shot up to a 3.1 when placed behind me.

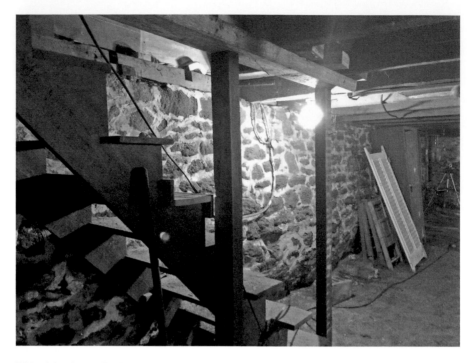

This old staircase leads to the basement of the Bridgeton Masonic Lodge. *Author photo.*

Because a Mel meter measures the electromagnetic field that is present in a certain area, to have the meter suddenly jump from the 0.1 and 0.2 readings that were recorded in the basement the entire evening to a 3.1 was definitely signaling that something—something that gave off its own energy—was there with us at that moment.

Investigating is very much like looking for pieces of a puzzle, and the goal is to hopefully put those pieces together. When an investigator has a personal experience and a piece of equipment such as the Mel meter backs up that personal experience, the pieces fit together and evidence of a haunting can be documented.

Earlier in the evening, while investigating the Masonic meeting room on the second floor—a place that women very rarely see—my fellow investigators and I heard quite a few unexplained noises.

When sitting quietly in the dark in an unfamiliar location, one where people have reported paranormal activity, it's easy for your eyes to play tricks on you. It's easy to get spooked, even though you try your hardest not to let the environment affect you negatively.

As I sat in the eerie meeting room, I saw what I thought was a figure standing in the corner of a small storage room just off the main hall.

When I saw the strange shadow out of the corner of my eye, I felt my body tense up. Who was this strange figure lingering in the shadows, watching us? Was the figure solid, or was it an apparition?

"Hello?" I called out to the shadow.

No response.

So, I gathered my courage and began walking toward the storage room. The two investigators who were in the meeting room with me followed my lead, and we approached the figure together.

I continued to speak to whomever might be standing in that dark corner until I reached the doorway.

With butterflies in my stomach, I turned on my flashlight and aimed it directly at the figure.

It was a mannequin wearing traditional Masonic garb.

We all had a good laugh and decided to sit in the storage room with our new creepy friend for a while to see if we could witness anything in the meeting room from that perspective.

It didn't take long for us to hear disembodied footsteps in the small hallway off the storage room just outside the meeting room.

Already having scared myself, I decided to go out into the hallway by myself and try to find the source of the footsteps.

I walked to the opposite side of the second floor, across the room from my fellow investigators, and sat down on a chair that was positioned there in a corner. The longer I sat in the dark, the more I doubted I would hear the footsteps again. Sometimes, if there is something present and the investigators move around or change positions, the spirits will get "nervous" and disappear.

But after a few minutes, I heard the footsteps again, in the hallway between the other investigators and me.

We never did debunk those sounds as something natural, so those footsteps remain unexplained.

PIRATES AND SUICIDES AND TEA BURNINGS, OH MY!

GREENWICH

There are certain small towns in New Jersey that seem to have a special energy about them.

One of those is the quaint village of Greenwich in Cumberland County.

Founded in 1684 after John Fenwick purchased the land from William Penn, Greenwich is one of the oldest ports of entry of colonial America.

Ye Greate Street was an Indian trail that led directly to the river, so while history says the town was laid out in 1684, the area was inhabited for many years before the known established date.

Today, as you drive south down Ye Greate Street toward the Cohansey River, a sense of timelessness comes over you, and you can practically feel yourself going back in time. The closer you get to the river, the older the homes become, and the atmosphere feels more and more magical.

With three centuries' worth of history, Greenwich has its share of tales and legends—some historical and some haunted.

One of the most notorious moments in Greenwich's history came on December 22, 1774, when the locals took revenge against the king.

I recently spent the better part of an unseasonably gorgeous winter day touring the town with lifelong Greenwich resident and annual Greenwich Ghost Walk tour guide Gregg Jones, who took me to the town square and the Greenwich Tea Party monument.

A view of Ye Greate Street in Greenwich, as seen today. *Author photo*.

Greenwich Tea monument. *Author photo*.

"Greenwich was an on-the-fence town," Jones explained. "Some of the people loved the British money, but others said, 'No, we have to stick together and go against the king.'"

When word got out that a large shipment of tea had arrived from England on a brig named *Greyhound*, a band of Patriots decided to destroy it.

"Word got out real quick—Paul Revere style," Jones said. "The boat was loaded down with tea. In Boston, they threw it in the water. Well, down here, we had matches."

Legend says that the Patriots dressed as Native Americans by smearing mud on their faces and wearing turkey feathers as accessories.

The tea was unloaded from the ship, put into wagons and taken down Ye Greate Street to the home of Dan Bowen.

The tea was put into a shed for safekeeping, but the Patriots found it, took it and burned it all in the center of town.

The monument, which bears the names of every man who participated that day, was erected in 1908.

"That was a monstrous thing here in New Jersey," Jones said. "I've seen pictures of men in straw hats and suits and ladies in big dresses standing in town square," Jones said of the day the monument made its debut. "They had a gigantic old American flag over the monument, pulled it off and unveiled it."

And for a small town, Greenwich has much more history that is just as exciting as their very own tea party.

"A town like this, you tend to have fairy tales and fables and guys just sitting around talking," Jones said. "I've lived here for sixty-four years. This was a mega cool town to be brought up in—working the farms, out in the fields and finding Indian graves. We used to go out in the woods, and there would be mounds of dirt. Some were Indian graves."

Jones continues to find old misplaced grave markers throughout the town, indicating that there are unmarked graves in farm fields, near homes and around just about every corner of the historic village.

So, naturally with the long history, hidden graves and notoriety, there are a lot of ghost stories that have circulated through Greenwich over the past three hundred years.

FERRY TAVERN INN AND JAIL

At the end of Ye Greate Street nearest the Cohansey River stands the remains of the Ferry Tavern Inn. Jones said the tavern was built in the 1680s.

"In the 1700s, there were close to thirty taverns in Greenwich," Jones said. "They were happy people."

Between the Ferry Tavern and the river stood the jailhouse.

"It was the oldest jailhouse in Cumberland County," Jones said. "[There were] guys coming in off the boats, and guys in here getting drunk and starting fights, so this is where the jail was built."

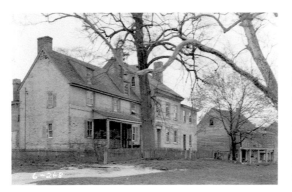

Left: Ferry Tavern Inn and Jail in Greenwich. *Historic American Buildings Survey*.

Below: Greenwich's Ferry Tavern Inn stands in disrepair today, but it was once a popular stop for sailors and fishermen who docked in the town. *Author photo*.

Men coming in off the water could eat and drink at the tavern and then stay the night in the guest rooms on the upper floors.

Today, the building is in disrepair, but work has begun to try to restore the beautiful and historic landmark.

Down the street just a few hundred yards is the Friends meetinghouse, where the Quaker congregation still meets to worship. Built in 1771, the beautiful brick building has maintained the original floors and pews, making this an amazing place to visit.

With all the beauty on Ye Greate Street near the river, it's hard to believe that a grisly mystery occurred there in 1778.

THE GREENWICH TERROR

George Loper, who wrote *The Ghosts of Greater Cumberland County* in 1992, told the story of a surprise attack on British soldiers who were camping near the river behind the tavern and meetinghouse on the night after the Battle of Quinton Bridge.

"British troops came here after the skirmish at Quinton Bridge," Jones explained. "They were heading up to Burlington because George Washington was up there at that time."

Jones said all the soldiers were asleep in their tents except for two men who were on guard duty.

"They were camped down for the night and had their rifles stacked.... They claim that a creature came out of the water. They heard a splash, looked over, and a hairy beast came out of the water," Jones said.

Loper wrote that the creature had glowing eyes and quickly approached the camp.

"The creature came out of the water and came upon the two soldiers," Jones said. "They started yelling. They shot at the creature. The soldiers all woke up in their skivvies half asleep, grabbed their rifles and started shooting."

In the panicked chaos, the soldiers ended up shooting and wounding one another but missed the creature alltogether.

"The last they saw of the two soldiers who were on guard was...they say the creature had one under each arm and went back into the water," Jones said. "You hear talk of the Jersey Devil and all that, so who knows."

Greenwich was once a bustling waterfront town with busy docks and ship traffic in Cumberland County. *Author photo.*

Warehouses once stood along the waterfront in Greenwich to store the supplies that were shipped to the many docks. Stone foundations are still visible behind Ferry Tavern Inn in Greenwich. *Author photo.*

A TOWN FULL OF STRANGE STORIES

There are many tales of unexplained activity along Ye Greate Street, some involving buildings that are no longer in existence and some that have occurred as recently as last year.

Jones said one story he has heard many times involves the Greenwich Fire Company building of today.

"I'm not sure how much truth there is to this one, but it's been handed down through the years," he said.

Back in the 1800s, a house stood where the fire company stands today.

"A Quaker family lived there," Jones explained. "The family was at their meeting, and one of the elder daughters wasn't feeling well, so she stayed home by herself. While they were at the meeting, the house caught on fire and the daughter perished in the fire."

Jones admits that he isn't sure how true the story is, but if there was a fire and a girl did die there, it's quite ironic that the fire company was built in its place.

Just a few doors down from the fire company is a two-story home that was empty and up for banker's sale as of this writing.

"A realtor was showing a family the house," Jones recalled. "This story just came to us within the past year."

He said while the adults were on the first floor, their young boy climbed the narrow staircase to the second floor.

"When his parents came upstairs, the boy asked, 'But what about Mr. So-and-so?'" Jones said, unable to remember the name the boy used. "The realtor was showing them the house, so the parents weren't paying much attention to what the boy was saying."

Jones said the boy brought the man's name up a couple more times.

"So, the parents were trying to work out a deal with the realtor, and the boy kept mentioning the man's name," Jones said. "The dad finally said, 'Who are you talking about?' And the boy said he met him upstairs."

Apparently, the boy relayed a story about going up the stairs and nearly stepping on this mystery man.

"The boy said, 'When I went up the stairs, I almost stepped on Mr. So-and-so's hand. He was crawling on the floor,'" Jones said.

The family never returned to the house.

While that dwelling was unoccupied at the time of this writing, many of the colonial homes in Greenwich are beautiful and lived in and loved, even if some of those homes have an extra tenant or two. Some of these centuries-

old structures are visited often, such as the home of the Cumberland County Historical Society museum, the Nicholas Gibbon House.

With so much history still alive in the quaint riverside town, it's no surprise that many of these buildings have hauntingly interesting tales attached to them.

THE PIRATE HOUSE

As one of the oldest port towns of colonial America, Greenwich has seen its share of sailors, fishermen and even pirates.

"There is legend that says Edward Teach, who was Blackbeard the pirate, did come up the Cohansey and did come through the Delaware Bay," Jones said. "As a kid, I looked real hard for that box of gold, and I never found it."

While it's not certain that Blackbeard left his treasure behind in Greenwich, another pirate did leave behind a ghost story.

Located on Ye Greate Street, neighboring the Warren and Reba Lummis Genealogical and Historical Library—home of the Cumberland County Historical Society office—is a beautiful two-story home known as the Pirate House.

Built in 1721, the Pirate House was home to Captain John Bowen, a known privateer and pirate.

"Captain Bowen had a crew, and it was well known back then that there were pirates here," Jones said.

Members of the colonial government knew Captain Bowen had taken up residence in Greenwich and didn't discourage his choice to live openly in the port town.

"This guy was a wide-open pirate. His being there discouraged British or Spanish ships from coming around," Jones said. "And they really didn't need to have any outsiders come around. It worked well for the government because the pirates scared people away."

Jones described Captain Bowen as "not afraid of anyone in town"; however, he eventually ran into trouble with his own men.

"One night, Captain Bowen was here divvying up the daily goods with these guys, and he didn't realize one guy besides him knew how to count," Jones said. "He was like, 'One for you, two for me. One for you, three for me.'"

Finally, a crew member caught on to what the captain was doing—not dividing the booty fairly among the band of buccaneers.

"So, they proceeded to beat the tar out of him, wrapped him up in chains and took him up into the attic and just left him there to rot," Jones said.

The rattling of chains has been heard in the house over the years and is believed to be the residual sounds of Captain Bowen's imprisonment and ultimate death.

"People move in and out of here quite a lot," Jones said, standing just outside the Pirate House.

When Jones was a teenager, he was witness to a strange occurrence while standing in just about the same spot.

"One mischief night, me and a friend—I'm not going to say the guy's name—but we were doing the soap-the-windows type stuff and toilet paper and Vaseline on the door handles," Jones recalled. "We're walking up the street, and Uncle Lew's gas station was open, so we stopped to get a soda."

The gas station, which was located at the Dr. Holmes House, was just across the street from the Pirate House.

The house has a lower level made of brick, with brick floors, which could have served as a kitchen back in colonial times.

"The lights were on in that lower area with the brick floor," Jones said. "My buddy said, 'Hey let's see if somebody's up and we'll grease up the door handle.'"

Greenwich's Pirate House was home to Captain John Bowen, a known pirate and privateer. *Author photo.*

So, his friend went and peeked through a window in that lower brick section of the Pirate House and got the scare of his young life.

"He went and looked in the window," Jones remembered. "Well, the next thing I know, he's screaming like a little girl and running down the street."

Jones caught up with his frightened friend a few houses down from the Pirate House and asked what was wrong.

"He said, 'I saw something,'" Jones said.

The friend said when he looked through the window, there was a "little old lady sitting in a rocking chair reading something."

"I said, 'So what?'" Jones explained. "But he said she was kind of freaky looking. And he was not a guy to run from stuff."

The following day, Jones began asking around town if the young couple who lived there had an elderly woman living with them or visiting.

"There was no old lady staying there," Jones said. "I could tell by my friend's reaction that he wasn't playing games with me. He wasn't acting. He was scared for real. I was satisfied enough when everyone, the next day, said that there was no old lady there."

NICHOLAS GIBBON HOUSE

Nicholas Gibbon was a maritime merchant who built the two-story—plus a basement and attic—brick home in 1730.

After Gibbon purchased the sixteen-acre lot where the home still stands, he constructed a replica of a London townhouse that he had admired while living in England. The bricks are laid in a Flemish bond pattern native to Kent, England. Rubbed brick outlines each door and window and can be found on the corners of the structure.

Considered a mansion, the Nicholas Gibbon House is the home of the Cumberland County Historical Society museum today and appears much like it did back in the 1700s.

The home features a reception hall, a paneled drawing room, a formal dining room and a kitchen with a walk-in fireplace where open-fire cooking demonstrations are still held.

The bedrooms are located on the second floor, and colonial toys, clothing and furniture are on display there.

"This place is tighter than Fort Knox when people aren't here," Jones said. "There's a security system, cameras [and an] alarm system."

Leonard Gibbon Homestead, now the Gibbon House Museum, with its historical marker in Greenwich. *Author photo.*

Greenwich's Gibbon House was built in 1730 by Nicholas Gibbon, a maritime merchant. *Author photo.*

Leonard Gibbon Homestead in Greenwich. *Historic American Buildings Survey (Library of Congress).*

However, there seems to be someone already inside the building who doesn't affect the security measures taken by the historical society.

"Up in one of the bedrooms, there's an antique rope bed," Jones said. "It's said that there was a lover's quarrel there many years ago, and there's a murder involved, but I don't know who it involved."

Several times over the years, when historical society volunteers open the museum in the morning, they see signs that someone has been in the building.

"They say sometimes, when people come here in the morning, like when the society opens on Sundays, that particular bed looks like the figure of a person had been laying in the bed sleeping overnight."

The impression on the mattress was the only evidence ever found that "someone" had been inside the building after hours.

The mystery of how the bed ended up appearing like it had been slept in remains to this day.

FRANCIS WOOD HOUSE

Having lived in Greenwich his entire life, Jones has memories stemming from nearly every nook and cranny of the colonial community.

But one house, the Francis Wood House, also known for serving as the office of Dr. Scheider, is the home where Jones was born and raised.

The house was built in the late 1800s and was the home and practice for Dr. Scheider.

"Keep in mind this was a doctor's house," Jones said. "But back then, the doctor's house in a town like this—there was no hospital—so people died in the doctor's house."

As a kid, Jones and his siblings enjoyed scaring each other as kids do, but he doesn't remember anything genuinely paranormal occurring inside the walls of his home. Nothing strange happened, in fact, until a life-or-death situation arose in 1974.

"I got married and moved out of the house," Jones said. "All the kids were out of the house. Mom was asleep, and Dad was at work. The chimney backed up, and the house caught on fire."

Jones's mother, Dorothy Jones, was sound asleep and unaware that her home was filling up with deadly smoke.

"She's sleeping away, and this fire is going on in the house," Jones said. "She's ninety-one now and swears to this day that she was being physically shaken that morning."

Jones said his mother felt herself being shaken and heard a mysterious voice.

"She felt physical shaking and heard a voice saying, 'Pauline, Pauline, you must get up,'" he said as he recollected his mother's description of the experience. "She woke up, and the house was full of smoke. She would have been dead in a few minutes."

But why had the lifesaving entity called his mother Pauline?

"Here's the crazy thing—my mom is Dorothy Jones, not Pauline Jones," Jones said. "I didn't know until I was in my fifties that my mom's real name is Pauline, not Dorothy. She is Dot Jones. Dorothy Jones."

But whoever was trying so desperately to alert Jones's mother to the impending danger had known her as Pauline.

"Who knows why?" Jones said. "It could have been the spirit of someone who had been there in the house, or Mom said maybe it was her mother waking her up. She didn't see anyone or recognize the voice, but she says it could have been her mother."

When loved ones pass away, we are told that they continue to watch over us. Perhaps, even though Pauline's mother wasn't associated with the Francis Wood House, she undoubtedly loved her daughter very much and knew she had to save the woman's life.

"Mom was a Pennsylvania girl," Jones said. "During World War II, she was a ship welder out in Pittsburgh. She was a Rosie the Riveter. She helped build the boats that landed at Normandy. Whoever it was saved my mom's life that day."

THE PUMPKIN HOUSE

Just a few more doors down Ye Greate Street is the Pumpkin House, which, according to Jones, is only named after the round, orange squash because it was painted orange for several years.

Built in the late 1700s, the Pumpkin House is located adjacent to the Richard Wood Store, which would become a significant part of the region's convenience store market.

"That is America's first official Wawa store," Jones said. "The Richard Wood Store. There used to be a Texaco gas station there, and it's also where the school bus would pick us up."

According to *Wawa*, a book in Arcadia's Images of America series by Maria M. Thompson and Donald H. Price, Wood built a general store on Ye Greate Street in the 1700s. This first store would spawn a business enterprise that Wood's descendants would eventually call Wawa—a favorite convenience stop that can now be found all over New Jersey, Pennsylvania and Delaware and a few locations to the south, now including Florida.

In the late 1800s, a young girl believed to have been named Amy died in the Pumpkin House.

When Jones was a child, a friend of his called the Pumpkin House home.

"I used to spend nights in that place when I was around twelve years old," he said. "We used to sleep upstairs. I never had a good feeling up there."

Jones didn't know this when he was a kid spending the night there with his friend, but for years after Amy's death, some of the people who lived at the Pumpkin House claimed they would feel someone twirling their hair or touching the back of their necks.

"Some people even said they could hear a girl's voice giggling," Jones said.

The activity increased over the years, and residents felt more and more like a child was in the room playing with them.

"Finally, someone got the idea to put a dollhouse and some toys up in that third floor," Jones said. "It did the trick. They said Amy stayed upstairs and didn't bother anyone downstairs again."

RICHARD WOOD MANSION

Richard Wood, proprietor of the aforementioned Richard Wood Store, which ultimately led to the creation of the Wawa enterprise, had a mansion built in Greenwich in 1795.

Jones said Wood had a smaller home built just a few doors down on Ye Greate Street to live in while the mansion was being constructed.

Once the mansion was completed, Wood and his son George B. Wood, a noted medical professional and writer, lived in it for many years.

"George and his father, Richard, were businessmen," Jones said, noting that the men were well off financially. "They were early merchants in the town and did business with British and colonial people as well. George, when people would hit hard times, he would loan them money to build a

Left: Wood Mansion in Greenwich. *Goodwin Family Collection*.

Below: Wood Mansion and the historical marker in Greenwich. *Author photo*.

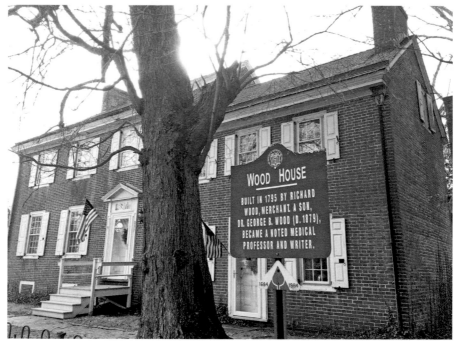

house or fix their house or stay in their house. He basically had a good heart but was also a businessman. And there were people who didn't care for him for that reason."

George died in 1879 after living a life he allegedly was secretly ashamed of.

"He died tormented with guilt because he kind of ripped some people off," Jones said.

Many years after Richard and his son George had both passed on, the Richard Wood Mansion became the home of the Cumberland County Historical Society museum.

"After the historical society moved up the street, the Wood family still owned [the mansion]," Jones said.

Because the family still owned the home, the portrait of George Wood was left behind.

"The portrait of him was found upstairs, but no one would put it out," Jones said.

Finally, a family moved into the mansion, found the portrait and decided to hang it over the fireplace in the downstairs sitting room.

A view of Wood Mansion in Greenwich, Cumberland County, through the iron fencing that surrounds it. *Author photo.*

Greenwich's Richard Wood Mansion is located on Ye Greate Street and is said to be haunted by Richard Wood's son, George. *Author photo.*

Once the portrait was brought out of hiding and placed on the wall, the home's atmosphere changed.

"People who lived there heard footsteps at night, heard voices, all sorts of weird stuff," Jones said.

Because he died tormented with guilt for what he had done to many of the townspeople, it is said that if you look through one of the windows in the Richard Wood Mansion when it's dark outside, you will see the sad face of George Wood staring back at you in torment because he knew that he wronged some people in life.

"The candles in the windows are lit up and on twenty-four seven," Jones said. "They always have the lights on. They claim it all started when they hung the portrait up."

CHARLES BEATTY FITHIAN HOUSE

On the northern end of Ye Greate Street, near Greenwich School, is a yellow stucco house that is also very familiar to Jones.

Jones's grandparents lived in the Charles Beatty Fithian House until they died and handed the home down to Jones's parents. The home and property is a spacious farm that was once dotted with barns and covered with fields and fields of crops.

"We just tore down the last barn last year," Jones said.

The home was built in 1799 as a narrow, two-story building. Over the years, several additions were built onto the original structure, similar to many of the homes of that era, many of which are located in Greenwich.

After both of his grandparents passed away and before his parents moved in, Jones was alone in the house painting on the second floor.

Alone.

"It was pretty creepy," he admitted. "My grandparents had died, and the house was empty and sort of run down a bit."

He had been in the house alone for a while, coating a room on the upper floor in color, when he began to experience a strange, unexplainable occurrence.

"All of a sudden, I heard a noise," Jones recalled. "I had the radio on, so I turned it off, and I heard it again. It sounded like a vibration."

At first, Jones thought he could have some company who was trying to play a trick on him.

He thought maybe his sister or brother was messing around, making the noise and trying to scare him, so he tried to call them out.

"'OK, knock it off,' I said. "If you're going to come here, grab a paintbrush and help me.""

The noise stopped but started up again a short time later.

"This noise is going on, and I'm painting and painting," Jones said. "Where's it coming from? They ain't giving up."

Determined to catch his mischievous siblings, Jones began investigating the entire second floor and realized that the attic was located directly above the room where he was working.

"They say the Underground Railroad came through Greenwich from the Delaware River," he said. "There were even smoking rooms upstairs where the meat was smoked. It's hard to say how many people came in and out of this house."

He walked through the second floor, by the narrow staircase, and once again heard the strange vibrating sound.

"I heard the noise behind me," Jones said. "Then, I saw that it was the attic door vibrating. I put my hand on the door and it stopped. I let go, and a couple minutes later, it started doing it again. It was like someone was pushing on it, but it was latched, but doing it very rapidly."

Jones finally realized the noise was not being caused by his brother or sister.

"I put the paint away and left," Jones said. "Like a good ghost hunter, I went back the next day to debunk it. It wasn't windy that night, but I thought maybe there was a window open or a window pane missing. I went upstairs and all the windows were shut. There were no panes of glass missing. Any of those reasons would have constituted the door vibrating like it was. But I couldn't find a reason why it was shaking. I don't paint here anymore."

HOUSE OF SEVEN SUICIDES

In Greenwich, the strange happenings aren't confined to only Ye Greate Street.

Located near the Greenwich Boat Works and Marina is a house known as the House of Seven Suicides. Built by sea captain Benjamin F. Maull more than two hundred years ago, the stately white house is shrouded in tragic mystery.

Jones said Maull had a business partner named Captain Mulford, and legend has it that Maull murdered Mulford at the House of Seven Suicides. The story goes that Captain Mulford began coming into success and didn't feel the rewards were being divided evenly between himself and his partner. So, he eliminated the only reason he was forced to share his profits.

"Maull murdered him," Jones said. "Then, later on, Captain Maull was so filled with grief and guilt that he hung himself inside the house. That was the first suicide."

Several years after the murder-suicide took place at the House of Seven Suicides, another seafaring fellow, Captain Hague, moved into the house with his family.

"One day, his daughter was found floating in the Cohansey River nearby," Jones said. "We don't know whether it was suicide, because she was distraught over being heartbroken by a guy, or other reasons. But they found her floating in the river and just don't know what happened there."

More recently, a man moved from Philadelphia to the House of Seven Suicides. He ran into financial trouble and hanged himself in the house, according to Jones.

"So, you have a murder, two hangings and a drowning," Jones said. "It's always been called the House of Seven Suicides, but [we] don't have any records for seven deaths. It's folklore, but those four are based on fact."

GREENWICH BOAT WORKS AND MARINA

Back in 1774, the brig *Greyhound* docked at the Greenwich Boat Works and Marina, where its load of tea from England was taken off the ship and carted to the teahouse on Ye Greate Street before the town's Patriots burned it all in the famous Greenwich Tea Party. The marinas and docks in Greenwich were very busy ports, and the town has seen millions of boats and sailors since it was settled in 1684.

The Greenwich Boat Works was once home to the Conquistador restaurant, which hosted great entertainment like Bobby Rydell, and it was also home to a boat building company. The marina is still filled with privately owned vessels that are stored there in the off-season and put into the water there during the summer.

In the middle of the marina parking lot, sitting among the many boats with names like *Princess* and *Twilight Zone*, is a single marker made of marble, honoring an unknown victim of the water surrounding Greenwich.

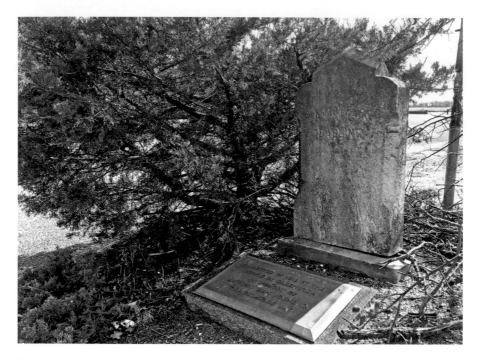

This marble headstone was erected in 1910 to replace the original wooden marker that was found there many years before. It reads, "A Mother's Darling," and was left in memory of a young man thought to be a sailor or fisherman who was found dead and floating in the Delaware Bay just off Greenwich's shores, Greenwich. *Author photos.*

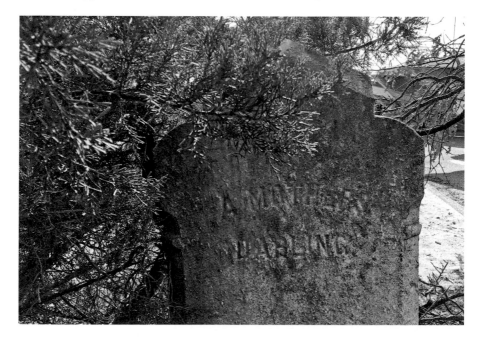

"Originally, there was a wooden marker there," Jones said.

In 1910, the wooden marker was replaced by the one that stands there today. In addition to the marker, a plaque was placed at its base that reads, "Erected in 1910 by the people of Greenwich in memory of a young man found in the Delaware Bay."

The marker—just as the original wooden one—reads simply, "A Mother's Darling."

"He wasn't a fisherman," Jones confirmed. "He was someone who fell off of a freighter, but he was never identified, so they just left that inscription on the new stone."

There are brief stories about the residential area near the marina, some that are rooted in the maritime trade business, some that are just strange.

Just up the street from the marina is a house that's considered possibly cursed.

"That house over there, the mom used to mess with those tarot cards and all that kind of stuff," Jones mentioned. "There just always seems to be hard times that come on people who live there. Nothing has ever been recorded; it's just a bad-luck house."

The line of houses located on the other side of the street from the marina has a funny name that most likely wasn't so funny for the many sailors who frequented those dwellings.

"It's called Bedbug Row," Jones said. "When sailors or fishermen came off the boats, there were ladies there. The men would come out of the houses—it wasn't the most sanitary place in the world—so most of the men left with more bugs than what they brought in."

While there are no recorded ghost stories about these two interesting areas, if the walls could talk, there would most likely be some terrifying tales associated with this waterfront community.

JAMES EWING HOUSE

Out on Old Mill Road stands the James Ewing House, built in 1773.

The ghost story associated with this home came directly from a witness Jones said he knows personally. "It was passed down from a lady I've known for years," Jones said. "She swears that one morning, she woke up, and there was a figure of a little Quaker lady standing at the foot of her bed."

According to Bessie Ayars Andrews, who wrote *Colonial and Old Houses of Greenwich*, there was a door in the "upper west room" that, at one time, led

into another second-floor room. During the many renovations that the house has undergone, someone built a wall close to that door, rendering it unusable, but still able to be opened slightly. Andrews wrote that the door would open about two inches before hitting the wall that was part of the next room, and the Quaker lady would come from behind it and stand at the foot of the bed.

"She swears to this day that she saw what she said she saw," Jones said.

James Ewing was a member of the Greenwich Tea Party crew who burned the shipload of tea that landed on Greenwich's shores from England. He was elected to the assembly from Cumberland County in 1778 and moved to Trenton in 1779, according to Andrews's book.

Ewing became mayor of Trenton in 1797 and attempted to change the way English words appeared when he penned the Columbian Alphabet in 1798.

The house he built changed hands many times over the years and was home to many people with popular Greenwich names, such as Ercurious Sheppard, Ebenezer Harmer and Wilmon Bacon.

THE THOMAS EWING HOUSE

"Resurrection Hall"

The "most notorious" of Greenwich's many haunts is associated with a home that was built by Thomas Ewing in 1707.

Thomas Ewing is the son of Finley and Jane Ewing, who fled Scotland during the religious oppressions and settled in Londonderry, Ireland, where their son was born. Thomas came to America when unrest came to Ireland and settled in Greenwich.

The Ewing Homestead, located on Old Mill Road, was once visited by Philadelphia's 6 ABC news reporter Don Pollock, who heard about the strange activity in the colonial home and decided to feature the house and its spirits in a Halloween television special.

The Ewing House was nicknamed Resurrection Hall after Charles Ewing—a descendant of Thomas Ewing—moved into the home. The house allegedly sat empty for many years before it underwent significant remodeling, bringing it back to life.

Note that many hauntings occur after an original home goes through changes during reconstruction. Perhaps something was stirred up when this hall was resurrected.

"A friend of mine used to live there in the '60s," Jones said. "He was a mechanic. He would put his keys on the table in the morning and go out to the garage to work. When he came back in, they would be missing, and he'd find them under a sofa cushion or in other strange places."

Jones said his friend would report other items also going missing or being moved from one spot to another.

"Weird stuff, but nothing but mischievous stuff," he said.

Jones said his friend would get frustrated with the entire house, saying things "grew legs and walked away" quite often.

About ten years later, Jones's friend left the colonial dwelling, and a young couple with a tiny baby moved in. The husband went to work every day while the wife stayed home to tend to the baby.

"She never felt comfortable in the house," Jones said. "She always had an uneasy feeling of not being wanted there. She would feel cold chills throughout the house, like when you stick your head in the refrigerator, and every now and then, she would get a whiff of a perfume that a lady would wear."

Jones said the young woman never felt anything physically touch her or heard or saw anything strange in the house, but she always had "weird feelings." There was no real evidence of a paranormal presence until finally, something made itself known.

"One day she was in the kitchen, and she had just fed the baby," Jones said. "The baby was in his high chair. She was doing the dishes, and all of a sudden she felt a very cold chill and smelled a strong perfume smell."

As she stood in the middle of her kitchen, frightened once again by the strange feelings she felt in the house, she received a warning.

"She heard a very audible woman's voice, and it said, 'Get out of my house.'…So, she proceeded to pick up her baby, walked out the door, walked down the street to the neighbor's house to use the phone and called her husband. She wouldn't come back in the house again, so within a couple weeks, they came back just to get their belongings and goodbye Charlie."

After the couple fled Resurrection Hall, it stood empty for a period once again, before another of Jones's friends took up residence in the now locally famous haunted house.

Jones said no one is sure who could be haunting Resurrection Hall, but it seems to be a resentful woman.

"Maybe she lost a baby herself," Jones said. "Who knows."

GLOSSARY

anomaly. An anomaly is an irregular or unusual event or an object that appears in photography or video that does not follow a standard rule or law or cannot be explained by currently accepted scientific theories.

apparition. An apparition is the image of a human that appears even though a physical body is not present.

digital audio recorder. Digital audio or voice recorders are used to capture audio evidence or electronic voice phenomena (EVP), which can be words, sentences or other verbal communication not typically heard by the human ear because the sounds are on a different frequency level from what the human ear can normally pick up. These recorders can be found in everyday department store electronics departments.

electromagnetic field. An electromagnetic field (EMF) is the natural energy field that surrounds all things, both natural and man-made.

electronic voice phenomena (EVP). Electronic voice phenomena are a part of what is known as instrumental transcommunication phenomena, or sounds and images that are found on electronic recordings or video. An EVP can be a disembodied voice that is not heard with the human ear but is recorded with a digital voice recorder or other audio recording device.

EMF meter. An EMF meter measures the electromagnetic field present in an area at a specific time. A high reading on an EMF meter can sometimes indicate a spirit is present.

entity. Anything that has a separate, distinct existence, though not necessarily material in nature.

haunting. A haunting is a reoccurring paranormal phenomenon that returns to a location when no one is physically present. Hauntings are usually focused on places, not people.

infrared video camera. An infrared or night vision camera records video footage in the dark. These cameras are used to detect energy or apparitions during a paranormal investigation.

intelligent haunting. An intelligent haunting involves a spirit that can interact with humans, manipulate objects and emit vocal communication. The spirit is aware of its surroundings and often attempts to communicate or make its presence known.

K-2 meter. The K-2 meter is a device used by electricians to detect fluctuations in an electromagnetic field. Everyday items such as electrical devices, cellphones and electrical boxes and wiring all naturally give off electromagnetic energy. The K-2 meter doesn't measure that energy but detects fluctuations in the energy.

Kinect video mapping system. The Kinect video mapping system is a skeletal recognition program that utilizes a Kinect video game sensor and laptop to detect figures, living or otherwise. The sensor emits thousands of laser light points that settle on the human skeletal system, especially the joints. The sensor transforms the laser points into a stick figure that is transmitted to a laptop monitor via a computer program.

Mel meter. The Mel meter is an instrument that measures both the electromagnetic field and temperature in a specific area. The Mel meter was invented by Gary Galka after his daughter Melissa was killed in a car accident when she was just seventeen years old. Galka's other daughter would frequently see Melissa sitting in her room, brushing her hair; Galka and his wife would feel her poking them; the doorbell would ring on its own;

and the television channels would change without assistance from a human. He also felt someone sit on his bed, but no one was there. Being an electrical engineer, Galka used his skills to invent the Mel meter, which is now used universally in the ghost hunting sector.

orb. An orb is a circular light anomaly that shows up in photographs or video footage but might not be seen by the naked eye. Orbs can be caused by dust, insects, moisture, reflections or lens refractions. Most orbs are caused by one of these naturally occurring situations but are often mistaken for evidence of the paranormal. A genuine spirit orb emits its own light, is not transparent and moves in a distinct pattern, usually not a straight line and not at a consistent speed.

paranormal. Paranormal is a term referring to something that is beyond the range of normal human experience or scientific explanation.

REM Pod. A REM Pod is a device that has four colored lights and an antenna that emits its own electromagnetic field. When that field is disturbed, the device uses the lights and audible tones to alert the user that the field has been broken.

residual haunting. A residual haunting is similar to a recording imprinted into the energy of a specific location. The spirit is not aware of its surroundings and does not interact with humans or other spirits. A residual haunting has been described as a cassette tape playing over and over again in time and space and involves a repeat of the same type of activity on a regular basis.

BIBLIOGRAPHY

Harris, Erika. "Woodnutt House." *Today's Sunbeam*, May 6, 1997.

Loper, George G. *The Ghosts of Greater Cumberland County*. Greenwich, NJ: West Jersey Literary Guild, 1992.

Rodia, Lauren. "Who May Haunt the Olde Stone House Village in Washington Township?" NJ.com, October 20, 2015.

Roncace, Kelly. "Are Prisoners Still Haunting the Gloucester County Jail?" Paranormal Corner, NJ.com, February 10, 2014.

———. "Barrett's Plantation House in Mannington: An Historic Experience." Paranormal Corner, NJ.com, April 28, 2014.

———. "Barrett's Plantation House Investigation." Paranormal Corner, NJ.com, February 4, 2013.

———. "Blueplate Restaurant in Mullica Hill." Paranormal Corner, NJ.com, May 6, 2013.

———. "Come Take a Legend Trip at Paradelphia.com." Paranormal Corner, NJ.com, September 8, 2014.

———. "Disembodied Voices and Light Anomalies Suggest Gloucester County Jail Still Houses Ghostly Prisoners." Paranormal Corner, NJ.com, March 10, 2014.

———. "Experiences at Olde Stone House Village." Paranormal Corner, NJ.com, March 31, 2014.

———. "Flashlight Conversation at Shady Lane Nursing Home." Paranormal Corner, NJ.com, November 23, 2014.

———. "Freemason Invite JUMPS to Investigate Their Lodge." Paranormal Corner, NJ.com, July 20, 2015.

———. "The Ghosts of Finn's Point National Cemetery." Paranormal Corner, NJ.com, November 2, 2015.

———. "Interaction at Finn's Point National Cemetery." Paranormal Corner, NJ.com, November 4, 2013.

———. "It's Hard to Question What Can't Be Explained." Paranormal Corner, NJ.com, November 16, 2014.

———. "JUMPS to Investigate Closed Gloucester County Jail." Paranormal Corner, NJ.com, January 27, 2014.

———. "Listen to an EVP Captured at Shady Lane." Paranormal Corner, NJ.com, February 23, 2015.

———. "Presence of Boy Felt at N.J. Plantation House." Paranormal Corner, NJ.com, December 14, 2015.

———. "Salem County Insane Asylum." Paranormal Corner, NJ.com, November 19, 2012.

———. "Startling Experience at Barrett's Plantation in Mannington Township." Paranormal Corner, NJ.com, November 11, 2013.

———. "Woodstown Tavern and Hotel." Paranormal Corner, NJ.com, March 4, 2013.

———. "Woodstown Tavern and Hotel Evidence Reveal." Paranormal Corner, NJ.com, March 11, 2013.

Stephey, M.J. "Freemasons: Facts vs. Fiction." *Time*, September 15, 2009.

Taniguchi, Lauren T. "Spooky Sites on Greenwich Ghost Walk Tour Spotlighted before Upcoming Hauntings." NJ.com, October 16, 2012.

"10 Most Endangered Historic Places in New Jersey 2012." *Preservation New Jersey*. Last modified 2012, preservationnj.org.

Thompson, Maria M., and Donald H. Price. *Wawa*. Charleston, SC: Arcadia Publishing, 2004.

"What Is White Noise?" HowStuffWorks.com. Last modified April 1, 2000. http://science.howstuffworks.com/question47.htm.

ABOUT THE AUTHOR

Kelly Lin Gallagher-Roncace is an entertainment and features writer for NJ Advance Media and NJ.com living in Pennsville Township, New Jersey. Kelly started her writing career as a news reporter at the *Today's Sunbeam*—a newspaper that covered Salem County. She switched directions and became a features writer for the *Today's Sunbeam*'s sister paper, the *Gloucester County Times*, in 2009. In 2012, the two newspapers, in addition to the *News of Cumberland County*, merged to become the *South Jersey Times*, covering all three western New Jersey counties—Salem, Cumberland and Gloucester. It was during her tenure there that she began writing about the unexplained in the weekly column "Paranormal Corner." In 2015, Kelly received a third place in entertainment column writing in the New Jersey Press Association awards. In 2016, Kelly was asked to join NJ Advance Media's entertainment team and now enjoys writing about paranormal legends and happenings throughout the state.

Visit us at
www.historypress.net
..
This title is also available as an e-book